Before and after the Horizon

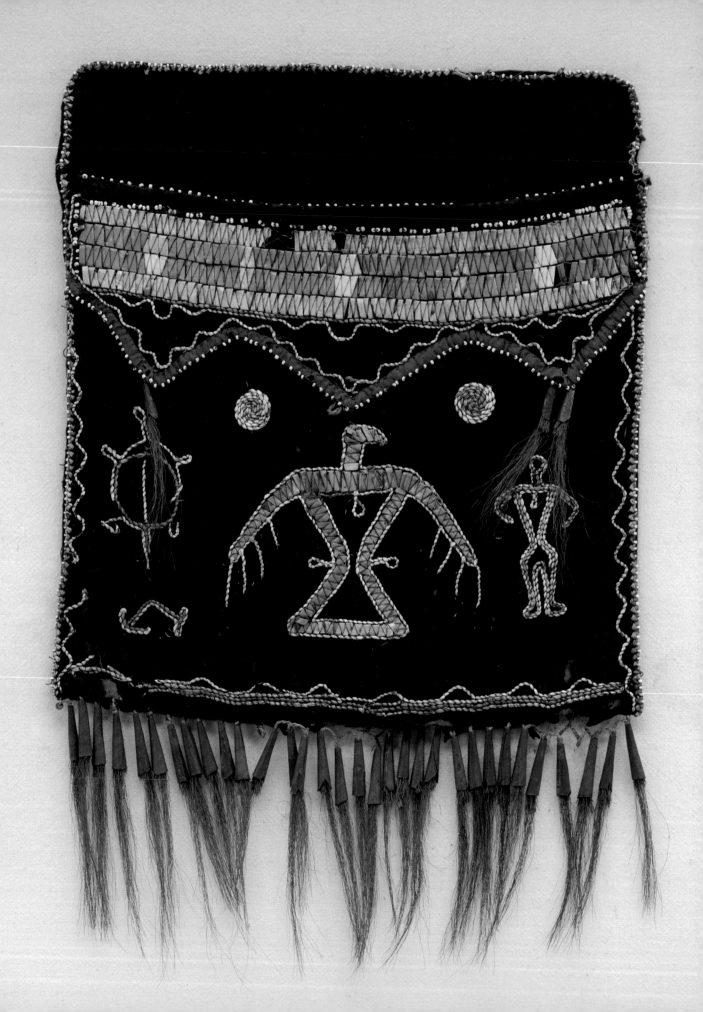

Before and after the Horizon
Anishinaabe Artists of the Great Lakes

General Editors: David W. Penney and Gerald McMaster

Published by the Smithsonian Institution's

National Museum of the American Indian

Washington, DC, and New York

Smithsonian
National Museum of the American Indian

Distributed by Smithsonian Books

This book may be purchased for educational, business, or sales promotional use. For information please write: Smithsonian Books, Special Markets, PO Box 37012, MRC 513, Washington, DC, 20013.

The National Museum of the American Indian is committed to advancing knowledge and understanding of the Native cultures of the Western Hemisphere—past, present, and future—through partnership with Native people and others. The museum works to support the continuance of culture, traditional values, and transitions in contemporary Native life.

Associate Director for Museum Programs
Tim Johnson

Publications Manager
Tanya Thrasher

General Editors
David W. Penney and Gerald McMaster

Project Editor
Sally Barrows

Editorial Assistance
Jane McAllister, Kate Mertes

Permissions
Ann Kawasaki, Bethany Montagano

Senior Designer
Steve Bell

First Edition
10 9 8 7 6 5 4 3 2 1

For more information about the Smithsonian's National Museum of the American Indian, visit the museum's website at www.AmericanIndian.si.edu. To support the museum by becoming a member, call 1-800-242-NMAI (6624) or click on "Support" on our website.

Published in conjunction with the exhibition *Before and after the Horizon: Anishinaabe Artists of the Great Lakes*, on view at the National Museum of the American Indian, New York, from August 10, 2013, to June 15, 2014, and at the Art Gallery of Ontario, Toronto, from July 26, 2014 to December 7, 2014.

Library of Congress Cataloging-in-Publication Data

Before and after the Horizon : Anishinaabe Artists of the Great Lakes / General Editors: David W. Penney and Gerald McMaster.

 pages cm

 Summary: "Illustrated with 70 color images of visually powerful historical and contemporary works, this book—which accompanies an exhibition of the same title opening in August 2013 at the National Museum of the American Indian in New York—reveals how Anishinaabe (also known in the United States as Ojibwe or Chippewa) artists have expressed the deeply rooted spiritual and social dimensions of their relations with the Great Lakes region"— Provided by publisher.

 Includes bibliographical references and index.

 ISBN 978-1-58834-452-6 (pbk.)

 1. Ojibwa art–Exhibitions. 2. Art, American–Great Lakes Region (North America)–Exhibitions. 3. Art, Canadian–Great Lakes Region (North America)–Exhibitions. 4. Great Lakes Region (North America)–In art–Exhibitions. I. Penney, David W., editor of compilation. II. McMaster, Gerald, 1953- editor of compilation.

 N6538.A4B44 2013

 704.03'973330074753--dc23

 2013016336

Printed in Canada

Contents

The Anishinaabeg and the Great Lakes

When Samuel de Champlain described his encounter in 1615 with a resident of an Anishinaabe community on the eastern shore of Lake Huron's Georgian Bay, he wrote, "I inquired in regard to the extent of his country, which he pictured to me with coal on the bark of a tree." With the exhibition *Before and after the Horizon: Anishinaabe Artists of the Great Lakes*, curators David W. Penney and Gerald McMaster ask Anishinaabe artists the same, albeit expanded, question: how can they reveal to us not only the extent of their country but also Anishinaabe perspectives on and experiences of it?

This question originated in a meeting that took place at the Detroit Institute of Arts in February 2008. The two curators assembled a group consisting of Alan Corbiere, then the executive director of the Ojibwe Cultural Foundation at M'Chigeeng First Nation, Manitoulin Island, Ontario; Robert Houle, a Saulteaux painter and former curator of contemporary First Nations art at the Canadian Museum of Civilization; Ruth Phillips, a Carleton University art historian; Adriana Greci Green, then on the faculty of the Northern Michigan University American Indian Studies Department; and artist Maria Hupfield to discuss the defining qualities of Anishinaabe art. The group focused on two considerations: language and place. While language proved to be a challenging basis for an art exhibition, the relationship between people and place, between Anishinaabeg and the Great Lakes, became a fruitful path. The group explored the question of how Anishinaabe artists have expressed the "extent of their country"—the histories, experiences, and stories of life in their Great Lakes homeland.

When David Penney became the associate director of museum scholarship at the National Museum of the American Indian (NMAI) in 2011, the exhibition came with him. Its emphasis on Native place in North America and its method of connecting the work of contemporary Native artists with the art of earlier generations are in keeping with long-standing museum goals. The project also gave us the opportunity to collaborate once again with former staff member Gerald McMaster, who between 2000 and 2005 worked with the NMAI's permanent collections and curated two exhibitions.

The title of the exhibition, *Before and after the Horizon,* evokes the work of twentieth-century Anishinaabe master George Morrison. The horizon line became a signature motif of his paintings. For him, it represented not only the place where earth, sky, and water come together in the Great Lakes landscape but also the border between what is perceived and what remains hidden, the known and unknown. This border, of course, shifts all the time depending upon one's vantage point. By choosing this title, we acknowledge that this exhibition and book can offer only a glimpse of the creativity and deep cultural knowledge generated by those affiliated with the many Anishinaabe nations. Guided by many friends, colleagues, and conversations, the curators chose not to attempt a comprehensive overview of Anishinaabe art or material culture. Instead they offer a vantage point, a perspective, a point of view.

Many helped, of course, but we wish to acknowledge in particular the Saginaw Chippewa Nation of Mount Pleasant, Michigan, and the M'Chigeeng First Nation of Manitoulin Island for their hospitality, support, and guidance during the early stages of this project. To them and to all Anishinaabe artists, including those we know and those whose names have become separated from creations now cared for in museums and collections, we say *miigwech!*

Kevin Gover (Pawnee)
Director, National Museum of the American Indian

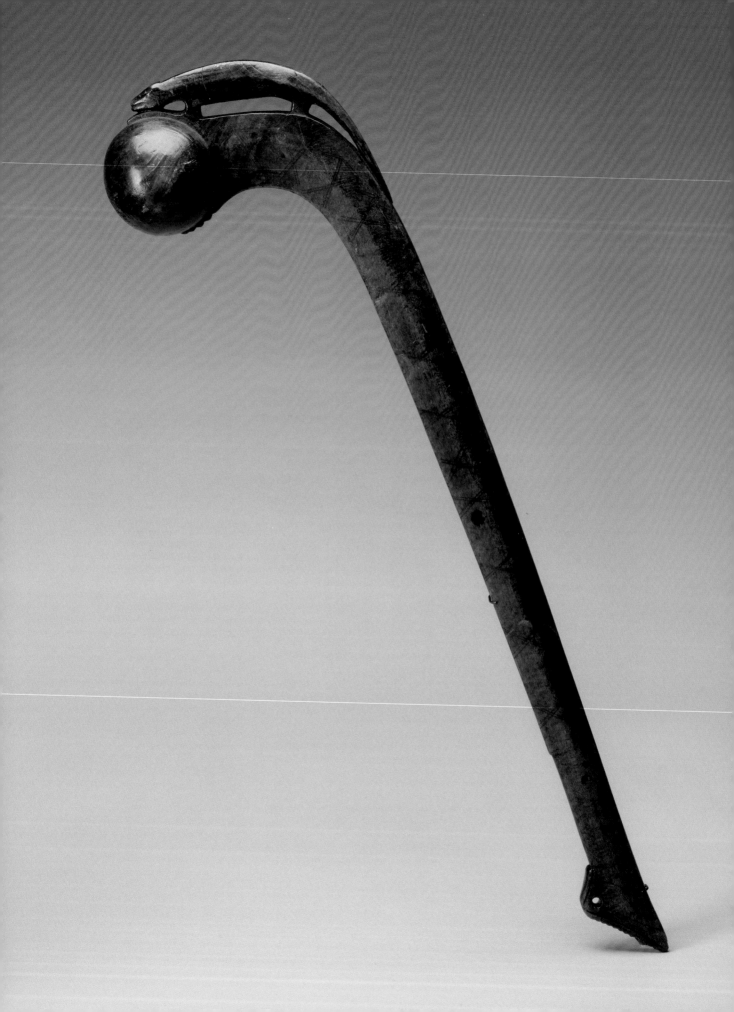

Water, Earth, Sky

The foundational story of Anishinaabe origin tells how our world was created from a few grains of sand. The previous world had submerged beneath a flood as a consequence of the triumph of Nenaboozhoo, the hero of the story, over the king of the watery underworld, an omnipotent, horned half feline/half serpent attended by snakes, bears, and monsters of various descriptions. His death at the hands of Nenaboozhoo, dressed in the skin of a frog and pretending to heal him but in truth avenging the death of his brother, created a torrent of water that flooded the world. But a few grains of sand, retrieved by an exhausted muskrat, were enough for Nenaboozhoo to build the land again. The world grew with Nenaboozhoo's travels, and he is still traveling, they say, still expanding our world. The shape and dimensions of the Great Lakes region are remnants of his wanderings and encounters with others during that primordial time. Another part of the story tells of his fight with Giant Beaver, who had dammed up the beaver pond that became Lake Superior. Nenaboozhoo burst the dam at what is now the outlet of the lake, at Sault Ste. Marie, and the water drained to form the rest of the Great Lakes. The crane, the elk, the beaver, the catfish, and other animals, birds, and fishes all scattered and found their places in Nenaboozhoo's new world, suspended upon primeval water. The ancestors of the animal species today, these mythic-scaled progenitors also are the founders of human lineages, each bound to its particular place and animal ancestor.

Relations between family, place, and animal ancestor are referred to by the term *doodem*, the source of the word *totem*, although that English word has been stretched and bent by anthropological theorists and popular culture to mean very different kinds of things. In Anishinaabemowin

Chippewa maker unknown. Ball-head club, ca. 1800. Wood; 66 x 7.6 x 17.8 cm. Collection of Richard Pohrt

(Anishinaabe language) the word *doodem* is an expression of ancestral relation to family members, near and distant, to animals of this and unseen worlds, and to particular places on the earth, tying back to stories of origins and how the world came to be. When Frenchmen first journeyed into Anishinaabe country, the people they met referred to themselves by their doodem, calling themselves, for example, people of the beaver, catfish, crane, elk, bear, or snapping turtle. Only later did these residents of the Great Lakes become lumped together by traveler/ethnographers, priests, commercial interests, colonial administrators, and other outsiders to become what are now known as the Ojibwe, Chippewa, Ottawa, Odawa, Algonquin, and Potawatomi. Collectively they called themselves Anishinaabe or Anishinaabeg (plural), which translate simply as *person* or *people*. By custom, through links with affinial kin (relations formed by marriage), by pursuing enterprising interests, and for countless other reasons, Anishinaabeg traveled: east to visit and trade with their relations and, later, European settlements; north to trade with their neighbors of the great salt bay (now Hudson's Bay); south to lands where corn, beans, and squash could be grown in abundance; and west, to the great rivers of the plains or out through the fringes of the forests in what is now Minnesota. Some would live far from their doodem places, mixed in with others but cemented into communities by generations of marriages. The land, the doodem, the family, the community, the language—these are the dimensions of Anishinaabe.

Over time, the modern nation states of the United States and Canada have forced the Anishinaabeg from much of their lands and left them with reservations or reserves—nearly 150 scattered across the Great Lakes—small parcels of land close among the ancient places, but each now administered as a separate band or nation. Some members of these communities continue to move, settling in towns and cities near and distant from their homelands, some traveling broadly to engage with the larger world, some remaining deeply tied to the ancient places of the Great Lakes and its environs. Some have been forced to forget, but many remember their doodem, their connection to ancient ancestors, ancient places, and all others who share their story of origin. Whether in home communities or scattered across the globe, whether enrolled or "heritage," more than three hundred thousand people living today identify themselves as Anishinaabe.

Some rightfully insist that being Anishinaabe is best expressed through language. Artist Robert Houle described how, "there is something distinctive about an Anishinaabe world view if you are a speaker." Language revitalization programs work today to raise the number of the more than

David W. Penney

Chippewa maker unknown. Drum, ca. 1840. Wood, deerhide, pigment; 53.3 x 52.7 x 7.6 cm. Collection of the Detroit Institute of Arts 1991.1022

Made to accompany songs of healing, this drum is painted with a design that shows the flow of power from thunderers to humans.

Chippewa maker unknown. Shoulder bag, ca. 1880. Glass beads, cotton, silk ribbon, wool yarn; 97.8 x 32.4 cm. Collection of the Detroit Institute of Arts 81.466

The central X pattern on this beaded shoulder bag refers to the breast and tail of the thunderbird; the spiky and jagged details evoke talons and lightning.

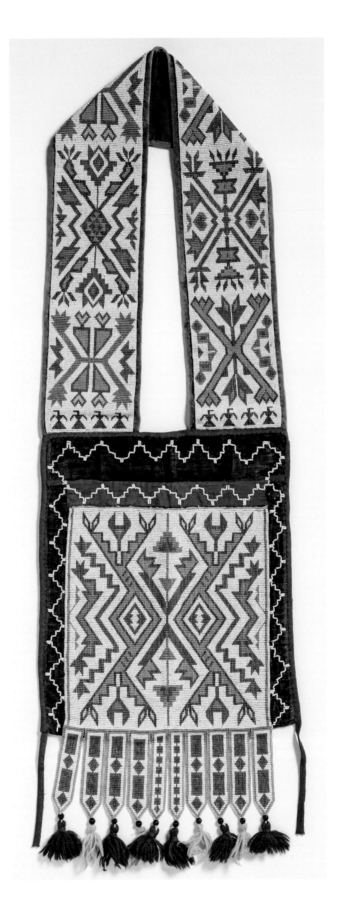

David W. Penney

fifty thousand who remain fluent in Anishinaabemowin. In addition to a language of words, however, there is an Anishinaabemowin of things, of relations with a material world that simultaneously shape and express a distinctive Anishinaabe identity. As that identity has come to be compared and contrasted with others, as the Anishinaabeg are understood as a distinctive culture among many cultures, Anishinaabe artists and the things they make have become instrumental in describing particular Anishinaabe relations to the land, to one another, and to those of the outside world. Anishinaabe stories, histories, and experiences of relations to the Great Lakes as a material and conceptual place can be perceived in some measure in the things made by Anishinaabe artists.

Two giants of twentieth-century Anishinaabe visual arts, George Morrison and Norval Morrisseau, illustrate this point. Morrison, raised on the northern shore of Lake Superior as a member of the Grand Portage Band of Chippewa, created a visual language for painting based upon a lifelong commitment to modernist artistic practice and urbane experience as one of the leading practitioners of abstract expressionism. While worldly in technique (he studied and taught modern painting in universities), his work almost invariably references the sky, water, and shore of his Lake Superior homeland. The Red Rock paintings, named for his studio on the Lake Superior shore, offer introspective meditations on the transient light that shimmers over the elemental substances of rock, water, cloud, and atmosphere. Weather- and water-worn driftwood add material and temporal dimension to his conceptual landscapes, arranged to create intricate shoreline topographies visible in Morrison's many wood collages. Although initiated as a series while in New England, Morrison later said that the origin of the wood collages lay in his homesickness for the Lake Superior shore and his childhood habit of beachcombing for driftwood. While Morrison eschewed any "Indian" references in his work, was it plan or coincidence that his signature horizon line, the structuring device for nearly all his art, corresponds to the horizontal strata of the traditional Anishinaabe cosmos, which is composed of water, earth, and sky?

Norval Morrisseau, on the other hand, taught himself to paint, beginning with touristic facsimiles of birchbark scrolls and vessels painted with colorful figures inspired by the vast lexicon of Anishinaabe pictographs. With the help of bookplate illustrations of Pablo Picasso, Henri Matisse, Maya steles, and Northwest Coast carving, and with the encouragement of more worldly gallery owners and anthropologists, Morrisseau expanded upon his gifts to create large, modernist paintings populated by human,

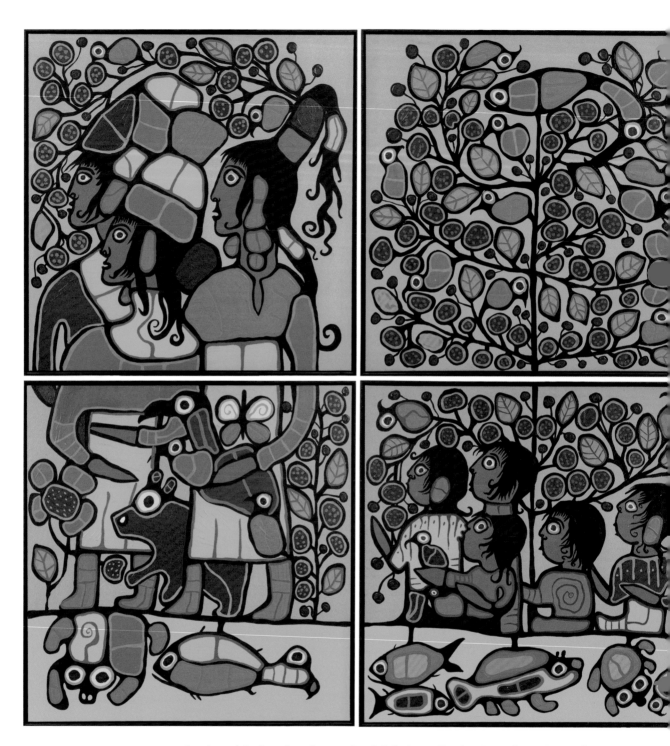

animal, and "other than human" spirit beings. During Morrisseau's youth, his grandfather had passed along to him traditional Anishinaabe religious teachings, and he had received spiritual gifts and the name Miskwaabik Animikii (Copper Thunderbird) after having been treated for disease by a traditional Anishinaabe healer. Morrisseau was deeply familiar with the traditional practice of signifying knowledge, for purposes of instruction

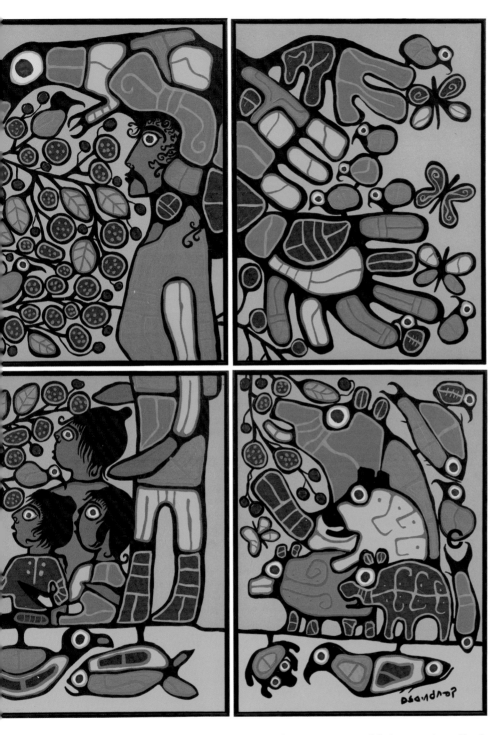

Norval Morrisseau (Anishi-naabe), 1931 or 1932–2007. *Psychic Space*, 1996. Acrylic on canvas; 243.8 x 426.7 x 3.6 cm. overall. Gift of R. E. Mansfield. National Museum of the American Indian 26/4085

or prompting memory, with images inscribed on birchbark scrolls or painted and carved into rock in sacred places. Morrisseau repurposed and elaborated on this pictographic form of representation, introducing in his work an interpretation of the Anishinaabe world view rooted in his individualistic philosophy and experience.

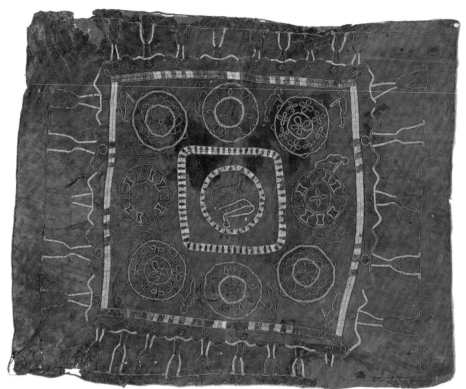

Odawa or Ojibwa maker unknown. Mat, 1775–1800. Deerskin, porcupine quills, dyes; 105 x 86.8 cm. Gift of Daniel Carter Beard. National Museum of the American Indian 14/3269

On this quilled deerskin mat, thunderers with arms extended like wings encircle the edges, while a pair of underwater panthers spiral around each other at center. In between is the terrestrial realm, here represented by human beings and what may be circular lodges.

Morrisseau's great insight, visible to us without the benefit esoteric teaching, is the transitive and relational nature of all things. In his most monumental paintings, his figures inhabit worlds in which they are inextricably immersed in states of transmission and transformation. He shows us an Anishinaabe vision of place that cannot be separated from the beings, human and nonhuman, material and immaterial, of which it is part, a place that is enacted rather than occupied. A related insight is prompted, perhaps, by Morrison's wood collages, in which wind, moving water, life that grows or rots by turn, enacts a world forever changing, forever in flux, impermanent and ephemeral.

"Power," that awkward term that approximates unseen, unperceived agencies, can be experienced to the extent that it acts. The violent thunderstorm, the cresting waves of the agitated lake—these are powers visible in effect but also, in rare instances, in person. Thunderers (*animikiig*) and underwater panthers (*mishibizhiig*) may manifest themselves in many different ways: as a gigantic raptor with lightning flashing from its eyes, dwelling within anvil-shaped thunderheads; as a horned monster resident beneath the waters, whose serpentine tail stirs up vortices and tempests; as lesser animals, humanlike beings, and disembodied voices; or in symbols and signs.

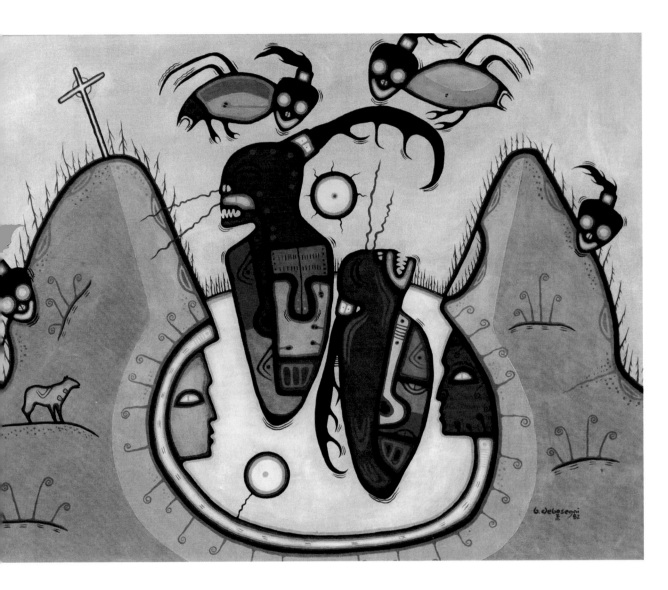

Blake Debassige (Ojibwa), b. 1956. *The Cross Hill*, 1982. Acrylic on canvas; 86 x 107 cm. Thunder Bay Art Gallery Collection with the assistance of the Walter & Duncan L. Gordon Charitable Foundation 86.1.11

Their effects are common but sightings rare. A story often told at M'Chigeeng First Nation, on Lake Huron's Manitoulin Island, recalls how Mishibizhiw raised his head from beneath the earth on a hilly outcrop. The resident priest was sufficiently alarmed to erect a cross there to protect the spot from future appearances. The site is known today as Cross Hill. M'Chigeeng artist Blake Debassige describes the event in his painting of 1982, showing two of the horned creatures rising between animated peaks, with thunderers hovering overhead.

The much younger artist Wally Dion reflected on the ever-present power of the thunderers and our modern dependency upon it with his collage of computer scraps and electronic parts arranged in mosaic as the familiar, iconic image of the thunderbird. Scientific consideration of the electric fields and charges that animate almost everything only seems to confirm

Wally Dion (Saulteaux),
b. 1976. *Thunderbird*, 2008.
Circuit boards, plywood,
acrylic paint; 121.2 x 296 x 9.4
cm. Collection of the MacK-
enzie Art Gallery, purchased
with the financial support of
the Canada Council for the
Arts Acquisition Assistance
Program

more ancient and time-honored Anishinaabe perceptions of power, broadly
named, and its potentialities. Electricity/thunder powers the world today
and arguably always has.

The sky, the earth, the water beneath, are indeed imbued with elemen-
tary powers, but Anishinaabe places also offer simpler if no less profound
gifts. Their materiality provided the foundations of Anishinaabe life, tied
to place by ways of living and traditional economies. Food, medicine,
shelter, sustenance all stem from knowledge of place and the practices
of living there. During the early and mid-nineteenth century, when the
United States pressured the Anishinaabeg to cede land, the treaties that
documented the transactions were explicit about the requirement that
the Anishinaabeg retain access to fishing places, hunting territories, sugar
bush, wild rice stands, and unsettled lands to gather traditional plants for
medicine and crafts. Fishing, wild ricing, maple sugaring, and blueberry
picking remained staples of Anishinaabe economic life well into the
twentieth century. Seasonal sugar making and berry picking in particular
offered substantive entry into the outsiders' markets. Many engaged with
the cash economies of the newcomers, working in logging camps and
as domestic workers, farmers, and wage laborers. Artist Patrick DesJar-
lait, from Red Lake, Minnesota, created a series of images of particular
Anishinaabe land-based economies with an artistic language informed
by instruction in graphic arts and illustration as well as familiarity with
American social realists and muralists of the 1930s and 1940s. His hero-
ically scaled figures work the land and lakes in family groups, enclosed
within nurturing cubist topographies.

Europe's original interests in Anishinaabe lands were economic.
Anishinaabe beaver trapping helped fuel the growth of the so-called

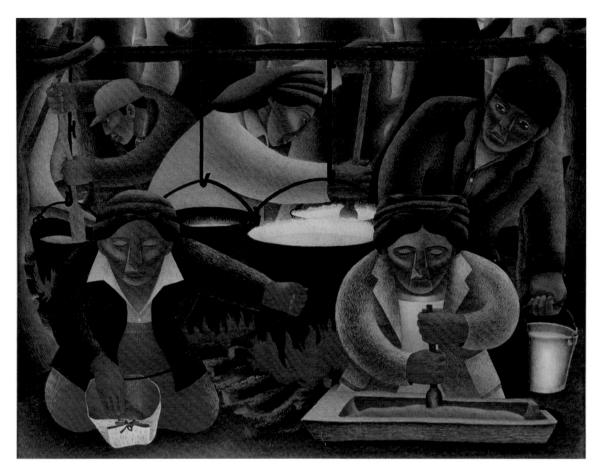

Patrick DesJarlait (Ojibwe), 1921–1972. *Maple Sugar Time*, 1946. Watercolor on paper; 38.7 x 51.4 cm. Philbrook Museum of Art, Tulsa, Museum Purchase

Patrick DesJarlait (Ojibwe), 1921–1972. *Basketmaker*, 1959. Watercolor on paper; 44.5 x 57.2 cm. Tweed Museum of Art, University of Minnesota Duluth, Sax Brothers Purchase Fund D2004.X4

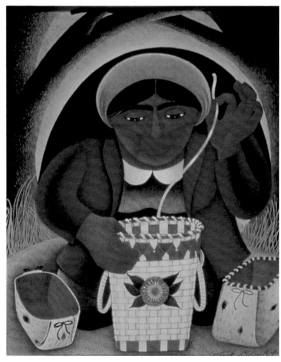

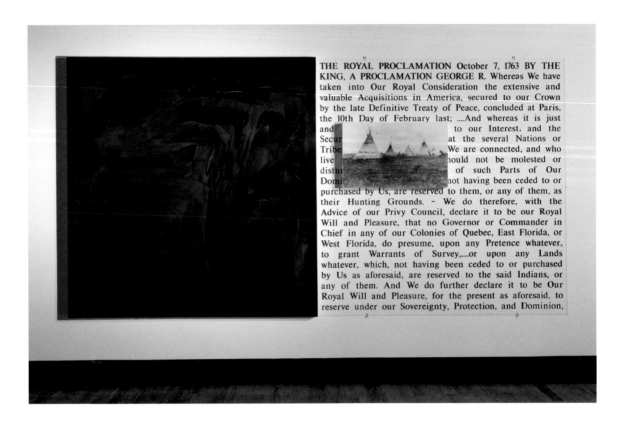

THE ROYAL PROCLAMATION October 7, 1763 BY THE KING, A PROCLAMATION GEORGE R. Whereas We have taken into Our Royal Consideration the extensive and valuable Acquisitions in America, secured to our Crown by the late Definitive Treaty of Peace, concluded at Paris, the 10th Day of February last;And whereas it is just and ... to our Interest, and the Secur... at the several Nations or Tribe... We are connected, and who live... ould not be molested or distu... of such Parts of Our Domi... ot having been ceded to or purchased by Us, are reserved to them, or any of them, as their Hunting Grounds. – We do therefore, with the Advice of our Privy Council, declare it to be our Royal Will and Pleasure, that no Governor or Commander in Chief in any of our Colonies of Quebec, East Florida, or West Florida, do presume, upon any Pretence whatever, to grant Warrants of Survey,.....or upon any Lands whatever, which, not having been ceded to or purchased by Us as aforesaid, are reserved to the said Indians, or any of them. And We do further declare it to be Our Royal Will and Pleasure, for the present as aforesaid, to reserve under our Sovereignty, Protection, and Dominion,

Robert Houle (Saulteaux), b. 1947. *Premises for Self Rule: The Royal Proclamation, 1763,* 1994. Oil, photo emulsion, laser-cut vinyl on Plexiglas, canvas; 152.4 x 304.8 cm. Collection of the Museum of Contemporary Canadian Art, Toronto, Canada

Atlantic economies, which arguably initiated our modern era. The global economies that grew from this foundation moved on to metallic ores, petroleum products, and other hard commodities. Finding their role forgotten and obsolete, the Anishinaabeg nevertheless refuse to leave the stage. A 1987 visit by the Duke and Duchess of York to old Fort William— now Thunder Bay, Ontario—at the head of Lake Superior, one of the old fur-trade depots, provided Anishinaabe performance artist Rebecca Belmore an opportunity to evoke the old partnerships. She wore *Rising to the Occasion* (not illustrated), a wearable work of art, in a performance with a group of other artists. The full-length dress, with a massive beaver lodge as a bustle, is made of cloth, beads, china, and other British commodities that infiltrated Anishinaabe lives through the early global exchanges. In acknowledgment of the old Anishinaabe alliances with the Crown, Belmore took care to imbricate within the fabric of the beaver-lodge bustle knickknacks and artifacts with specific references to the royal family.

Once upon a time the British Crown had proposed a more equitable division of North America, establishing the Proclamation Line of 1763 as the western boundary of British colonialism and settlement. In the United States, it ran along the crest of the Appalachian Mountains and through eastern New York State, leaving almost all Anishinaabe land off-limits to

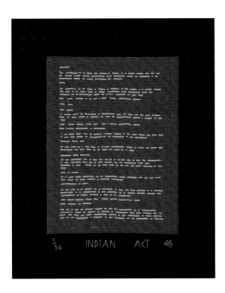

Nadia Myre (Anishinaabe),
b. 1974. *Indian Act,* 2000–03.
Glass beads, Stroud cloth,
acid-free paper, masking
tape, thread (pages 7, 20,
26, 27, and 28 of a 56-page
work); each page, 20.3 x 30.5
cm. National Museum of the
American Indian 26/7723

British settlement.
The thirteen colonies
fought their War
of Independence
to erase it. In one
of a series of works
entitled *Premises for
Self Rule,* Canadian
painter and Anishi-
naabe intellect Rob-
ert Houle evokes the
Proclamation Line
in text and textured

paint as one of several such missed chances. Reams of paper
documents created since then—treaties, acts, surveys, admin-
istrative directives, and regulations—have imposed often
unwelcome dimensions on Anishinaabe lives. Nadia Myre's
project of community healing through art-making confronts
one of the most consequential of such documents: the Cana-
dian Indian Act of 1867, the administrative realization of
Canada's racist policies. Myre enlisted scores of volunteers
to cover each printed page of the Indian Act with rows of
glass beads, embroidering them onto the document's surface,
erasing or overwriting its culture-destroying policies with
patient, meticulous, culturally rooted labor.

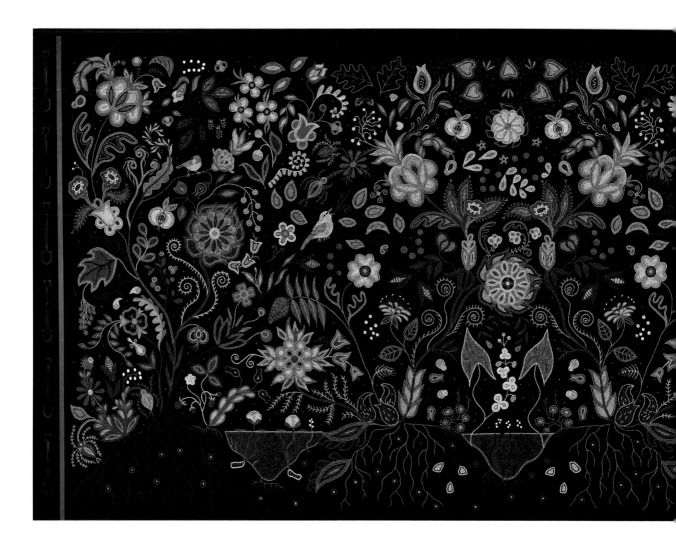

The French, English, and Americans, to some degree, like the Haude-
nosaunee, Cree, and Dakota, presented permeable cultural boundaries
for the Anishinaabeg. As they have for the Anishinaabeg and Wendat,
whose coexistence on the southeastern Ontario peninsula has been
archaeologically well documented, and for the thoroughly mixed Oji-Cree
communities of the northwest lake lands, history and experience on the
Great Lakes have long knit together Anishinaabeg and Europeans, so
much so as to spawn nations of Métis, the "mixed-blood" descendants of
Anishinaabe and European unions. Flower images and floral decoration, a
European design vernacular imported on printed textiles (cotton calicoes)
and taught in mission schools, are a sign of Great Lakes and Prairie Métis
identity for artist Christi Belcourt. Her mural-scaled acrylic paintings of
floral design, executed with beadwork-like pointilism, are intended to
evoke the epic experiences of her Michif/Métis ancestors, the prairie and
Great Lakes fur-trade workers, also called the flower beadwork people.

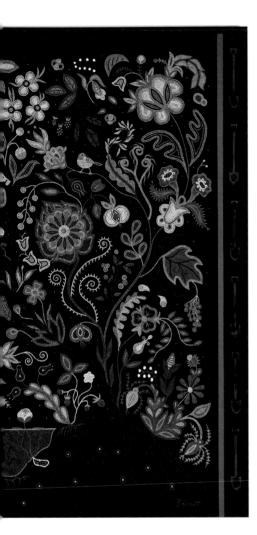

Christi Belcourt (Michif/Métis), b. 1966. *So Much Depends upon Who Holds the Shovel,* 2008. Acrylic on canvas; 125 x 248 cm. Aboriginal Affairs and Northern Development Canada Art Collection 500053

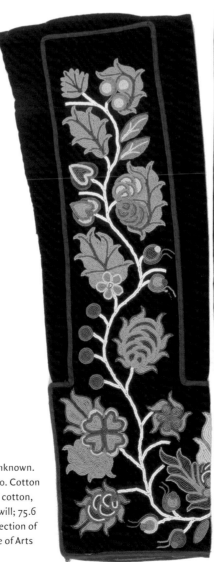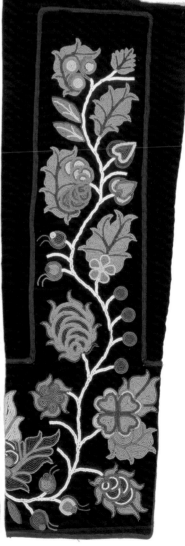

Chippewa maker unknown. Leggings, 1885–1900. Cotton velveteen, polished cotton, glass beads, wool twill; 75.6 x 28.3 x 1.6 cm. Collection of the Detroit Institute of Arts 81.181.A-B

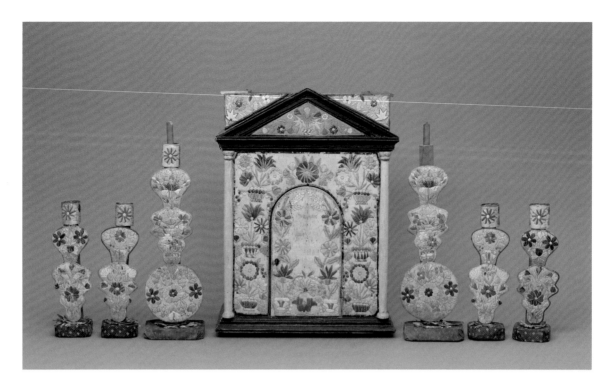

Odawa maker unknown.
Tabernacle and candlesticks,
1840. Wood, birchbark, porcu-
pine quills, fiber. Tabernacle,
69 x 33.5 x 50 cm; candlesticks,
34.9 cm and 50.2 cm high.
Weltmuseum Wien

Many Anishinaabeg, inspired by tireless missionaries, became devout Catholics (or Lutherans, or adherents of other denominations). There had long been a Catholic community at L'Arbor Croche (Crooked Tree), or Cross Village, as it came to be called, on the shore of Lake Michigan. A tabernacle for an altar installed at the village's mission church, made in the 1830s or 1840s, is embroidered with porcupine quills to create intricate floral compositions. One can imagine that the creators of this unique arti- fact of Odawa Catholicism believed they had deployed signs of Christian civilization in their choice of the floral motif. Later generations would subvert any such assimilationist implications when using floral images on ceremonial regalia, shoulder bags, leggings, and dance aprons, stressing instead ties to medicinal knowledge and traditional symbolism. Floral regalia may now express a full range of Anishinaabe experience.

After the traders, the miners, the loggers, the priests, and the admin- istrators came the vacationers. The rise of Great Lakes cities such as Chi- cago, Detroit, and Toronto led to the desire of its more affluent citizens to find temporary respite from urban drudgery in the remote, picturesque "wilderness" of the region's more distant locales. Accessible by railway and steamboat, Saugatuck, Harbor Springs, Mackinac, Killarney, Pointe au Baril, Little Current, and other resort towns, nestled in picturesque bays close to long-established Anishinaabe communities, became sum- mer destinations, with the construction of hotels, homes, and cottages

Ojibwa maker unknown. Wall pocket, late 1800s. Birchbark, porcupine quills, vegetal fiber, thread; 37.3 x 14 cm. National Museum of the American Indian 25/441

beginning for the most part in the 1890s. For the fur trade, generations of Anishinaabeg had worked the canoe transport in the interior as guides, canoe makers, and provisioners. They converted these skills easily to serve the desires of visiting sportsmen as hunting and fishing guides, outfitters, and suppliers. Anishinaabeg were enlisted as both part of the attraction and the logistical support of summer cottager communities. Working as guides, domestics, and handymen, or selling food and handicraft products door-to-door or at roadside stands, markets, and fairs, Anishinaabeg contributed to the touristic "branding" of the Great Lakes. Broad Indian stereotypes concealed general poverty as well as institutional attacks on Anishinaabe culture, language, access to the land base, and other consequences of racist attitudes and policies. Compulsory attendance at residential schools and prosecution (in violation of federal treaty agreements, as the courts proved much later) of Anishinaabe "poachers" tended to erode the foundations of Anishinaabe culture even while tourist economies celebrated it.

Access to tourist markets supported generations of artists and fabricators of handcrafted canoes, snowshoes, rustic furniture, carvings, black ash baskets, and birchbark boxes. Birchbark boxes embroidered with porcupine quills first entered tourist economies as packaging for the individual portions of maple sugar offered to patrons of the Great Lakes steamers. The sugar was packed in miniature *mokuks*, the traditional lidded boxes for food storage. Victorian tastes for knickknacks, curiosities, and souvenirs led to experimentation and innovation, with artists creating particularly elaborate constructions such as footed boxes, trays, miniature steamer trunks, canoes, houses, Indian lodges,

Anishinaabe maker unknown. Miniature furniture, late 1800s. Birchbark, porcupine quills, cotton thread. Chair, 10.2 x 7.6 x 7.6 cm; table, 7.6 x 17.8 x 10.2 cm; couch, 10.2 x 22.9 x 11.4 cm. Tweed Museum of Art, University of Minnesota Duluth, Richard E. and Dorothy Rawlings Nelson Collection of American Indian Art, Gift of Richard E. (Dick) Nelson EL2006.3maf.346a-h

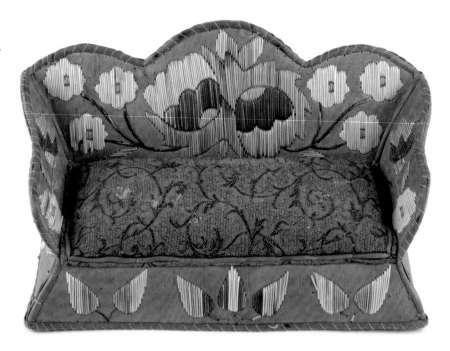

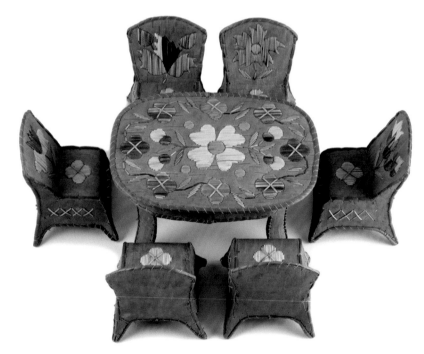

sewing baskets, wall pockets, handbags, and countless other forms. Colorful sprays of flowers or, more rarely, geometric patterns and pictorial images decorate them; composed of porcupine quills that have been sorted, dyed, and softened, the decoration is meticulously applied to the birchbark surfaces. Ever watchful for the opportunities of novelty, some artists proffered topical subjects such as Mickey Mouse, Donald Duck, or Santa Claus. As the particular, detailed knowledge and skills involving

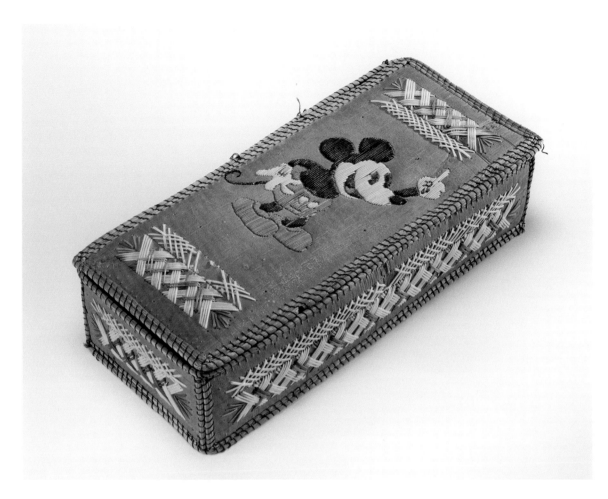

Anishinaabe maker unknown. Box, 1930s. Birchbark, porcupine quills, sweetgrass, thread; 6.7 x 26.5 x 11.5 cm. Canadian Museum of Civilization III-G-1454 a-b

Odawa maker unknown, Cross Village, Michigan. Birchbark house, late 1800s. Birchbark, porcupine quills, spruce root, braided cedar root, thread; 18.4 x 22.2 x 19.1 cm. Collection of the Graham Family

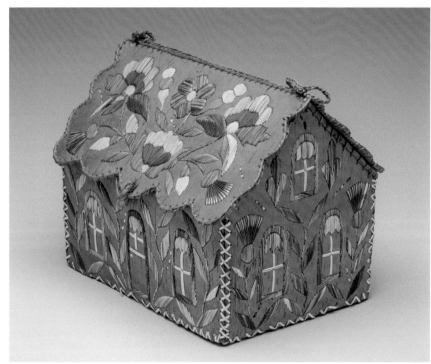

Ottawa maker unknown. Miniature chest, ca. 1840. Birchbark, porcupine quills, spruce root, fabric, thread; 12.7 x 25.7 x 14.5 cm. Collection of the Detroit Institute of Arts 2008.34

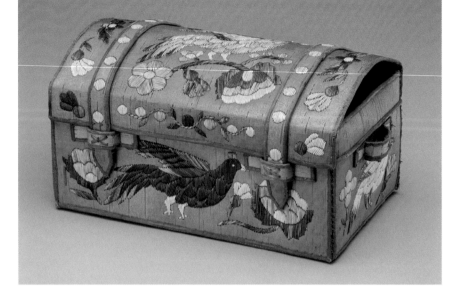

Yvonne M. Walker Keshick (Odawa/Ojibwe), b. 1946. *To Our Sisters*, 1994. Birchbark, porcupine quills, sweetgrass; 13.3 cm high x 20.6 cm diam. Michigan State University Museum

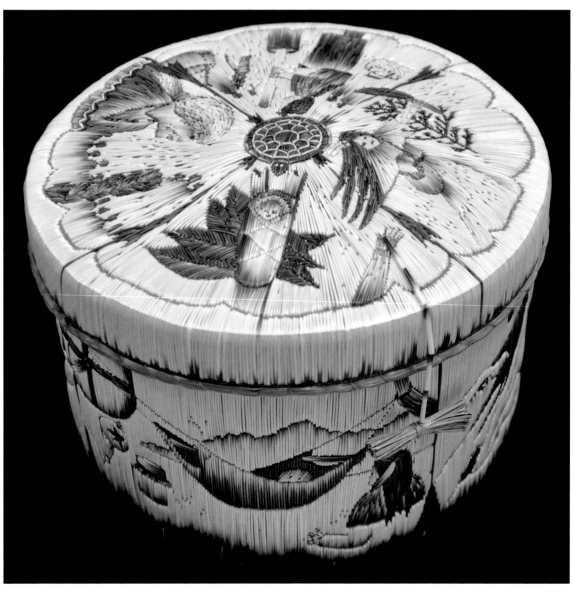

Angus Trudeau (Odawa),
1908–1984. *Manitou Georgian
Bay*, ca. 1970s. Mixed media
on canvas; 53 x 94 cm.
Aboriginal Affairs and North-
ern Development Canada Art
Collection 306036

Angus Trudeau (Odawa),
1908–1984. *Manitou, Tobermory,
Ont.*, ca. 1970s. Mixed media
and collage on paperboard;
71.9 x 101.7 cm. McMichael
Canadian Art Collection,
Purchase 1996, 1996.2

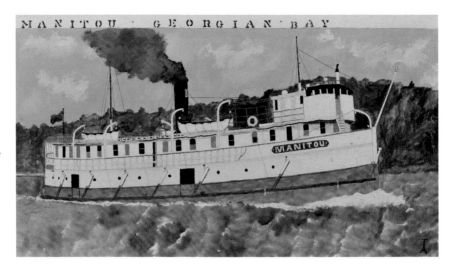

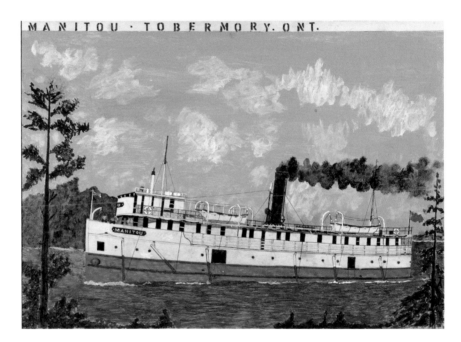

the collection and preparation of materials, construction, and design have
been passed down from generation to generation, the tradition continues
today. Michigan artist Yvonne M. Walker Keshick of the Little Traverse
Bay Band of Odawa makes ambitiously scaled boxes solidly sheathed in
undyed quills, their natural dark-to-light coloration arranged to give tone,
shade, and texture to her lifelike human figures and animal forms.

Self-taught Manitoulin Island painter and ship worker Angus Trudeau
created a unique art form for the summer visitors: large, brightly colored
paintings of the Northern Navigation Company's iconic passenger ships,
which trafficked between the southern cities and the resort ports of the
north. He based the images on postcard photographs of the ships but

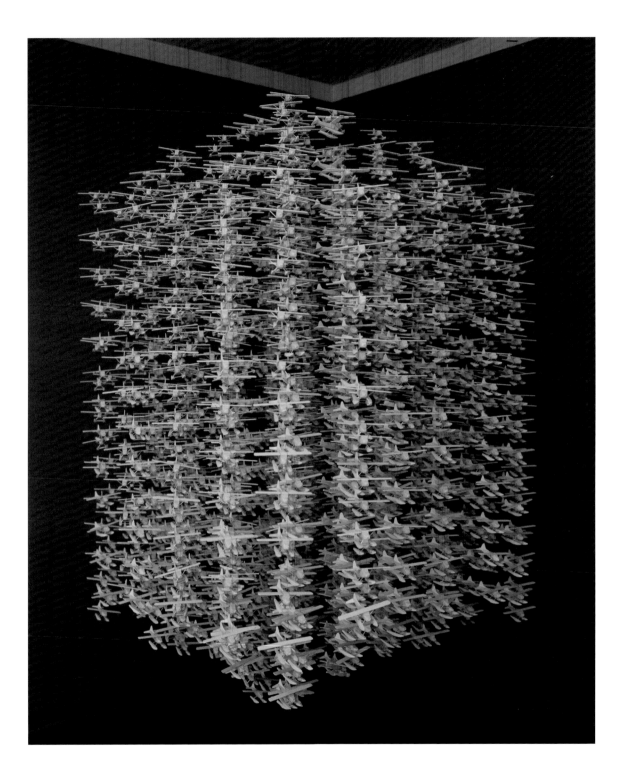

added variations of setting, with the ships either dockside or cruising forested shores, people crowding the decks. A half-century later, artist Frank Shebageget seems to take up the same theme of the mechanical conveyances that reach into Anishinaabe country, now in the context of the fine arts gallery. In his large mobile, *Beavers,* the (de Havilland DHC-2)

Frank Shebageget (Anishnabe), b. 1972. *Beavers*, 2003. Basswood and metal; 142.2 x 243.8 x 152.4 cm. Collection of the Ottawa Art Gallery: purchased with the support of the Canada Council for the Arts Acquisition Assistance Program, Glen Bloom, and OAG's Acquisition Endowment Fund, 2005

See page 104 for an additional image of *Beavers*.

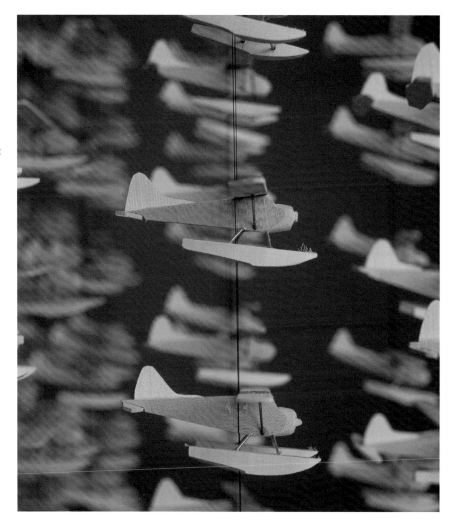

Beaver in question is the workhorse floatplane that now services the most inaccessible interior areas of Anishinaabe lands. Made of balsa, his model floatplanes, arranged in a mobile grid, swarm like bees. But of course, this is a two-way flyway and always has been. In the three hundred years since Anishinaabe chiefs converged on Montreal for the Treaty of 1701, the journey has only become more convenient and ubiquitous. Anishinaabe actors played Paris with George Catlin in 1845. But residential schools, searches for jobs, relocation programs, and opportunities for higher education did the real work of moving Anishinaabeg outward to Detroit, Minneapolis, Toronto, and elsewhere.

Infiltrating the United States and Canada, many Anishinaabeg now populate urban centers, largely invisible to outsiders. Wally Dion's *Nurse Tracy*, dressed in hospital scrubs, performs her role as one of the thousands of health care professionals whose humanity and individuality are summarized by a clip-on name tag. Dion appropriates the visual language

Wally Dion (Saulteaux),
b. 1976. *Nurse Tracy*, 2008.
Acrylic on wood panel; 121.9
x 98.4 cm. Collection of the
Canada Council Art Bank

of Soviet social realism, giving her a heroic scale and stature as a means
of emphasizing the shoulders of the family and ancestry upon which she
stands and the generations of trials and challenges contained in and yet
concealed by her professional persona. Indians in modern settings remain
challenging for the rest of the world to imagine, so photographer Keesic
Douglas muses on how the world might visualize contemporary Indian
living. His meticulously constructed "lifestyle" photographs offer us a
fantasy of fashionable young Indian professionals in an urban apartment
with just enough truth to make the mirage convincing and desirable.
Minneapolis artist Frank Big Bear Jr. reflects on the old stereotype of
living in "two worlds": Indian and white. "Many Indians say they live in
two worlds, but they actually have to live in more than two worlds," he

Keesic Douglas (Ojibway), b. 1973. *Lifestyles*, 2007. Chromogenic print; 76.2 x 76.2 cm. Collection of Keesic Douglas

says. "If you live in one world you are pretty much stuck in one place. Right now I'm living in the cab-driving world, the Indian world, the sober world, the art world. The more worlds you live in, the better it is." His figures are created with assemblages of highly personal signs, symbols, and images that reflect the complexity of contemporary humanity.

Anishinaabe artists offer us snapshots of an Anishinaabe world view, and yet an emphasis on personal perspective emerges as a powerful characteristic of "Anishinaabe art." The points of view are as varied and individualistic as the life experiences of the artists. In this slice of Anishinaabe artistic production, the concept of place as a spiritual and ancestral homeland ties the works together. Land and people change, but the place remains the same.

David W. Penney

Associate Director of Museum Scholarship,
National Museum of the American Indian

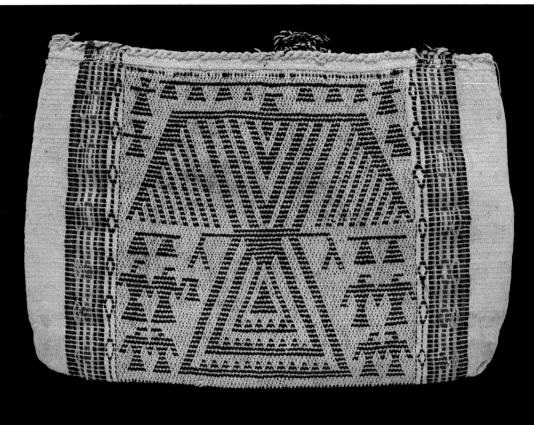

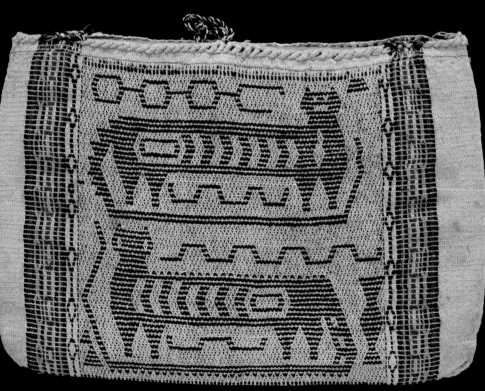

Animikii miinwaa Mishibizhiw

Narrative Images of the Thunderbird and the Underwater Panther

To the Anishinaabe eye, the world expands outward in layers. In each of the cardinal directions are the four winds. Above hangs the tiered sky with its unseen currents, traversed by celestial bodies. Below are the lightless strata of earth and water, with their secret folds and highways. In this traditional conception, humans inhabit only the thin middle slice of a many-layered world peopled with powerful beings. The *animikiig* (thunderbirds) rule the sky: lightning shoots from their eyes, and thunder is their cries and the flapping of their wings.[1] The thunderbirds' counterparts and nemeses (and often prey) are the *mishibizhiig* (underwater panthers), great cats with serpent tails and horns, who govern the subsurface realm of lakes, rivers, swamps, caves, and earth.[2] Though they represent polar opposites in the Anishinaabe cosmos, their diversity demonstrates a degree of fluidity between upper-world and underworld roles: for instance, flying lions of fire and thunderbirds who travel through the folds in the earth.

These two great beings remain well-known features of Anishinaabe culture. Our purpose is first to show that they are not generic characters in an arbitrary collection of stories and motifs, but rather, distinct characters in an orderly system of interrelated oral traditions and visual signs. Second, we wish to explore the sky/subsurface relationship as being complex and complementary rather than a Manichean dualism. Using an Anishinaabe framework for interpretation, we turn to the methods that Anishinaabeg traditionally used to transmit knowledge and ideas: *aadizoo-kaanag* (stories of the Anishinaabe oral tradition) and their visual complement, picture language (seen in a multitude of mediums, from birchbark scrolls to cliff faces to clothing).

Potawatomi maker unknown. Bag, ca. 1890. Cotton twine, wool yarn; 43.2 x 64.8 cm. Collection of the Detroit Institute of Arts, Founders Society Purchase 81.372

This twined bag features an hourglass-shaped thunderbird. The reverse side of the bag features two underwater panthers.

ORDERLY ABSTRACTIONS

The ethnologist Frances Densmore once asked an Anishinaabe elder to render the name Giizhigokwe (Sky Woman) in the picture language. The old woman hadn't heard the name before, and went alone to consider the image. The drawing she created was not a literal rendering of the words *sky woman* but a scene, with two women inside two circles. She explained:

> This name means that there are really two women instead of one. In the sky is one of these women; the other is on the earth. But the woman in the sky is constantly giving spirit power to the one on the earth, which the one on the earth reaches out her hand to receive.[3]

Densmore had been following a link between Anishinaabe songs and the pictographs etched on song boards.[4] She had found that symbols associated with specific songs were universally understood among the members of the Midewiwin (Grand Medicine Society). Further, the basic unit of this visual language was not the individual word, but rather, a culturally embedded narrative—aadizookaan. These narratives were widely and consistently understood within communities (though comprehension among communities varied), enough so that people could make readable signs and marks by referencing this canon. Densmore's research confirmed this within the Midewiwin society, but the same system encompasses more general signs, such as directions left for family members,[5] marks on cliff faces to warn travelers of underwater panthers, or thunderbird designs worked into personal items.

Though the range of this visual language is by no means limited to thunderbird and panther imagery, there is a rich body of such material to draw from. A great number of objects bearing these motifs (such as quilled shoulder bags and twined fiber bags) exist in collections today, originating from a period of prolific production between the mid-eighteenth and early nineteenth centuries. This was a time of great upheaval for the Anishinaabeg, as the fur trade waned and alliances changed. Within this context of uncertainty, objects bearing strong traditional imagery were perhaps intended to invoke—diplomatically and spiritually—a distinctly Anishinaabe power. [6]

Objects from this time represent a rich and distinctive spectrum of thunderbird and underwater panther symbolism, ranging from clearly representational figures to puzzling abstractions and geometric objects (zigzags, hexagons, diamonds, square meanders, etc). Ted Brasser, researching a collection of quillwork-embroidered shoulder bags at the Canadian Museum of Civilization, proposed that the consistency in composition

Ottawa maker unknown. Bag, ca. 1800. Tanned, black-dyed hide, wool cloth, porcupine quills, animal hair, metal cones, sinews, cotton. Bag, 23.5 x 18.5 cm (excluding fringe); strap, 100 cm. Canadian Museum of Civilization III-M-6

Quillwork shoulder bag with underwater panther, perhaps shown in the "folds of the earth"

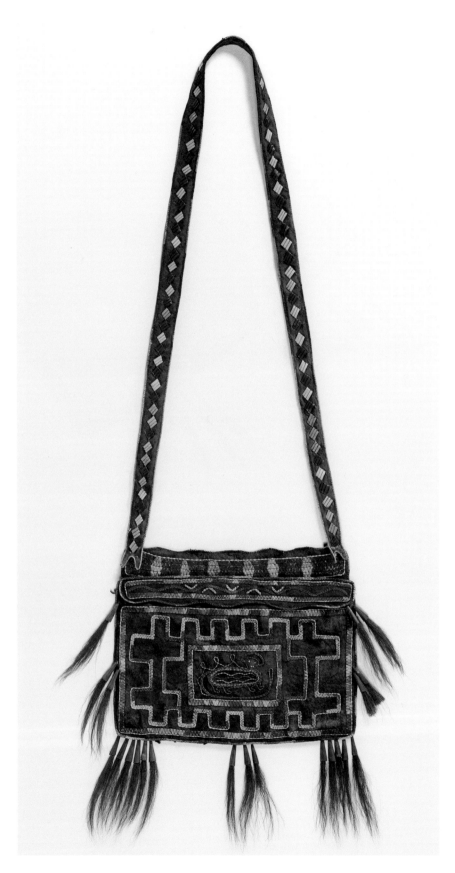

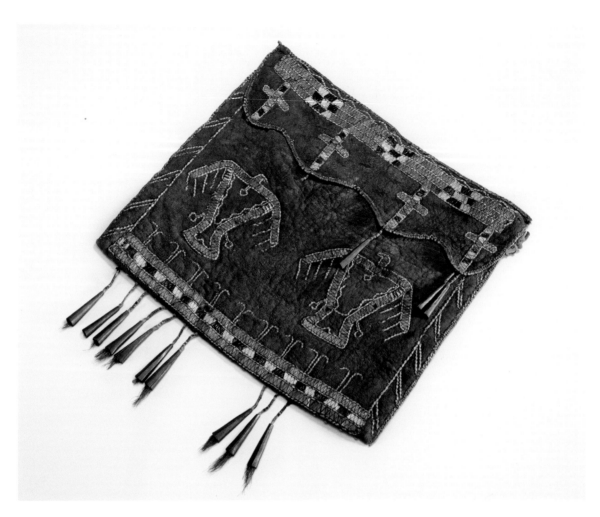

Odawa maker unknown. Pouch, pre-1800. Tanned, black-dyed hide, porcupine quills; 22 x 25 cm. Canadian Museum of Civilization III-G-829

Quillwork shoulder bag with two hourglass-shaped thunderbirds

Winnebago maker unknown. Bag, pre-1925. Wool, cotton string; 47.6 x 59 cm. Canadian Museum of Civilization III-O-2

Twined bag featuring hourglass shapes, the abstracted forms of the thunderbird's body

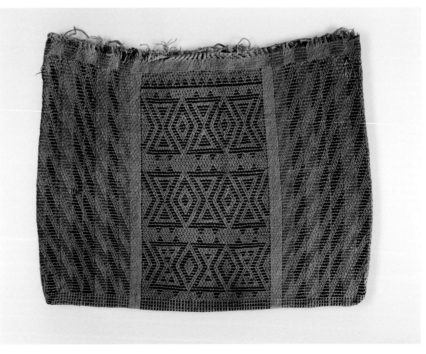

across a great number of the bags indicated that a system was in place, that there was meaning to these images. He saw the system as having two distinct, opposing sets of symbols relating to either the thunderbird or the panther.[7] Ruth Phillips, examining the same system of symbols on twined fiber bags, noticed that certain abstract motifs correspond to representational motifs. A thunderbird, for example, might be represented in different states of abstraction, ranging from a bird with spread wings and tail to a simplified hourglass shape to the suggestion of many hourglass shapes in a meandering line. The underwater panther might be represented by a four-legged horned creature or by an octagon (whether indicating its tracks or the eddy it creates when surfacing or diving). Abstract designs factor as much as the representational elements in constructing meaning.[8]

These interpretations find well-established support in Anishinaabe oral tradition, where beings are often described allegorically. The underwater panther, for example, may emerge from a swirl of water, or may not even appear, though its approach is made known by the swirling. In the Anishinaabe "re-creation" legend, Nenaboozhoo goes to exact revenge on the underwater beings for his nephew's death. He disguises himself as a stump on the beautiful sandy shore. He calls for a calm, clear, hot day, and waits for the underwater beings to come sun themselves on the shore.

Zhigwa bi-ishpagoojinoon iniw giizisoon, owaabandaan gagizhibaajiwaninig i'iw zaaga'igan.

When high the sun was risen, he beheld moving circles upon the water of the lake.

Nitam omagakiin mooshkamowan, gaye go anooj igo i'iw isa mani-doo, gakina awiya mii go i'iw bemiizhagwaadaanid i'imaa minisi-nadaawangaanig.

First a toad came up to the surface, and then the various manitous; every living being then came forth from water out upon that island of sand.

Inaabid Nenabosho, pane go gaawaasaadigosenig.

While Nenabosho was looking, everywhere was there splashing of water.

Ningoding sa baamaa go naawagaam wenji-mooshkamonid; gonigi-niin, mishibizhiin!

By and by all of a sudden far out upon the water something came up to the surface; behold, (it was the) Big Lynx![9]

The word used here for the water's motion is *gagizhibaajiwan*. The initial morpheme is *gizhibaa*, which means to swirl, spin, or revolve; the suffix *-jiwan* refers to the current or flow of water. With the addition of *ga-* to the beginning, the word conveys continuously swirling water. It is this motion, preceding the emergence of the panther, that is perhaps represented by the octagon or hexagon on some twined bags.

An elder of M'Chigeeng First Nation named Elizabeth Panamick recalled that one summer in her childhood, as she and her friends played on a bridge over a river, the water below began to swirl. One of their mothers came running to them:

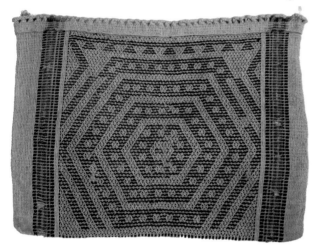

Anishinaabe maker unknown. Twined bag, 1800–1809. Nettlestalk fiber, animal hair, wool yarn; 60.4 x 42 cm. Jasper Grant Collection, National Museum of Ireland 1902:327

Twined bag featuring the "swirl" motif of the underwater panther

"Nbiish maanpii . . . gaawii maamdaa wii-dkambatoowaang. Nbiish maanpii ndaa'aagmishkaa," ndi-naanaa sa.
"The water here … we can't run across. The water is swirling here," we tell her.

"Yaa-aa!" kida sa wa mdimowenh. "Gjib'oweg!" kida. "Wiya zhiwi yaa," kida sa.
"My God!" says that old lady. "Run away!" she says. "There's somebody there," she says.[10]

The swirling water is a door to the underworld but also a warning, a symbol that says, "There's somebody there." This whirlpool symbol stands for the subsurface realm in many examples of Anishinaabe art, including a twined fiber bag in the collection of the National Museum of Ireland.

The bag's panel shows a spreading swirl on the water as the panther is about to arrive. Above the swirl, we can also see the abstracted image of the panther's opposite: a row of nine trapezoids (or the bottom halves of hourglasses). These shapes suggest the tails of hovering thunderbirds, waiting for the emergence of their prey.

BEARING A PIECE OF SOMETHING UNBEARABLE

The twined fiber bags described by Phillips and referenced above provide a particularly interesting perspective on the sky/subsurface relationship because they are two-sided, with the thunderbird realm always depicted on one side and the panther realm on the other. In some examples, though, motifs from the opposing realm subtly break the dividing line in ways that intentionally play on the division between worlds.

A twined bag at the Detroit Institute of Arts is a prime example, with symbols explicitly belonging to the opposite realm incorporated into each

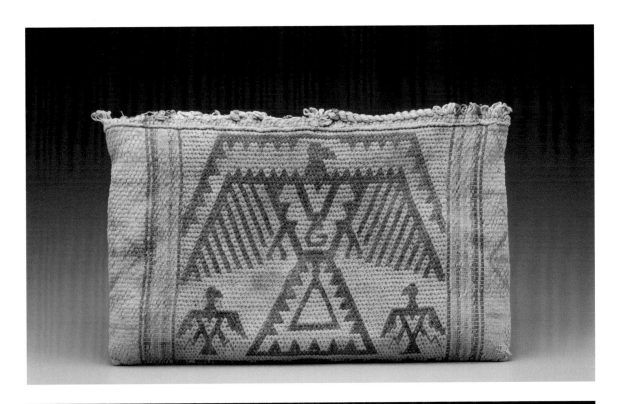

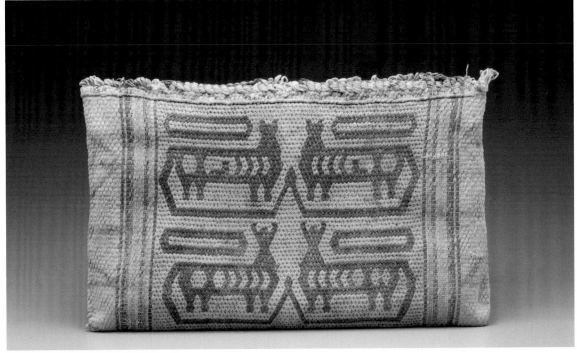

Ottawa maker unknown. Twined fiber bag, ca. 1870. Vegetable fiber and wool; 34.6 x 55.9 cm. Collection of the Detroit Institute of Arts 81.37

This twined fiber bag features the "G" thunderbird, whose heart resembles the whirlpool motif. The reverse side of the bag depicts underwater panthers containing hourglass motifs.

side. This visual device may represent the Anishinaabe adage that everyone must bear within them something unbearable. This is a concept traditionally relayed through the stories of the *wiindigoo,* as in the following by elder Maude Kegg, recounting her grandmother's words:

> **Mii dash i'iw gii-ikido: "Ani-ziigwang, mii ganabaj a'aw onaabani-giizis, mii azhigwa ani-gagizhaateg, mii ezhi-ningizod," ikido, "maa-gizhaa gaye mikwamiin awiiya iidog gegishkawaagwen."**
> And she said: "When it's beginning to be spring, perhaps in March, and it's starting to warm up, then it melts," she says, "the ice he must bear within himself."[11]

In a footnote to this story, editor and transcriber John D. Nichols noted that, "Maude Kegg explains that we can each bear within ourselves a sample of something that we cannot tolerate; in the case of a windigo, this is ice."[12]

The wiindigoo is a dreaded being created when the spirit of starvation takes over someone's body in the hard winter months, and he or she begins to prey on other people. The heart of the afflicted person is said to turn gradually to ice—that is, to take on an aspect of winter and starvation itself, the antithesis of life. This is the wiindigoo's unbearable burden.[13]

We see this concept reflected in the subtly placed symbols on the thunderbird bag from the Detroit Institute of Arts. On its sky-realm panel, a thunderbird in the characteristic hourglass shape spreads its wings under the vault of the sky, flanked by (presumably) two children shooting lightning from their feet. The ridges (perhaps ruffled feathers) on the shoulders of the mother bird suggest agitation. All three have the usual arrowhead heart, but the central thunderbird also has a G shape—or a swirling symbol. It bears the sign of its nemesis's emergence in its heart; something of its opposite.

The same theme is reflected on the bag's reverse. The subsurface panel depicts two male and two female panthers, with the two females distinguished by their shorter horns and apparent pregnancy. Within each of them, opposite the chevrons of their ribs, is an hourglass. Consider the exact words of elder Maude Kegg regarding the wiindigoo: *"maagizhaa gaye mikwamiin awiiya iidog gegishkawaagwen;* the ice he must bear within himself." The root word *gagishkawaa* is translated in the Ojibwe dictionary as "to bear someone on one's body, be pregnant with someone."[14] This specific Ojibwe word communicates that, in a very literal sense, the wiindigoo must bear the ice within him—in the same way a woman bears a child, the thunderbird bears a swirling doorway to the underworld, and the panther bears an aspect of the thunderbird.

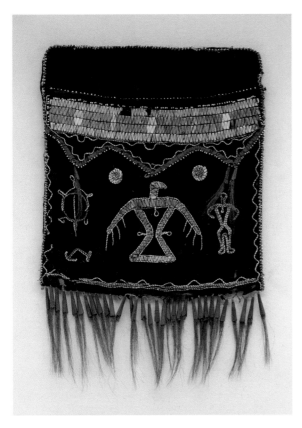

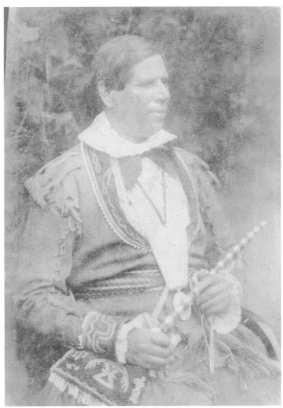

Ojibwa (Mississauga) maker unknown. Bag, ca. 1800. Hide, porcupine quills, silk, hair, tinned iron, vegetal cordage, glass beads; 35 x 27 x 4 cm. Collection of Mr. and Mrs. Charles Diker DAC 586

Peter Jones's quillwork bag

Hill & Adamson. Reverend Peter Jones in traditional attire, including a quilled bag, August 4, 1845. Salted paper print from a calotype negative; 21.1 x 15.2 cm. The J. Paul Getty Museum, Los Angeles 84.XO.608.16

DIVISIONS AND ALLIANCES

Unlike the twined fiber bags, quilled shoulder bags feature designs on only one face, so the upper and lower realms are instead represented in vertical zones. In fact, each bag describes a cross-section of the layered Anishinaabe cosmology, with various characters acting within it. The quilled shoulder bag that belonged to Peter Jones (a prominent nineteenth-century Methodist minister and Mississauga man) features a large raptorial bird flanked by a turtle and a man, with two circles floating above. Interpreting the design as a reference to Jones's clan (Eagle) accounts for the bird but neglects the human and the turtle. We should instead look for a relationship between these figures, placing Jones's identity within a framework connecting raptors, reptiles, and humans.

The relationship between turtles and thunderbirds is often tacitly referred to in the aadizookanag (oral narratives) in a way that implies opposition. Grandparents will warn their grandchildren not to capture snapping turtles in boxes as pets, as doing so would "call the thunderers." Perhaps they are attracted by a trapped enemy or the sight of an easy meal.

A legend recorded in 1893 by John Esquimaux of Manitoulin Island, called "The Between People" tells of a young Anishinaabe man who marries a woman from the subsurface realm. Seeing her new home on dry

Plate 57

Drawn by Capt S Eastman U S A

Lith Printed & Cold by J T Bowen Phil

PICTOGRAPHS ON LAKE SUPERIOR AND CARP RIVER MICH.

Illustration by Seth Eastman for Henry R. Schoolcraft, *Historical and Statistical Information Respecting the History, Condition, and Prospects of the Indian Tribes of the United States,* (Philadelphia: Lippincott, Gambo, 1851), 1: 407, plate 57

Chief Shingwauk's rendering of a local pictograph, reproduced in Henry Schoolcraft's notes. The turtle in the lower half of the drawing labeled with the number 8 is shown as a serpent wearing a shell.

land, the woman asks, "Is this going to be our dwelling place all the time? I could not live here long. First time the thunders come they will surely kill me for food, I must have protection." The young man makes a strong new wigwam out of stone, but he needs a door that can stop the thunderbirds. For this purpose, he finds a turtle in the mud of an inland lake. Hanging it in the doorway, he tells it, "I want you to be a door keeper for me. Never permit anyone to come in without knowing who he is." The turtle agrees. The underwater woman (perhaps an underwater panther or serpent in a changed form) needs protection against the thunderbirds, and it is the turtle who has that power.[15]

Reinforcing this interpretation, a pictograph drawn by Chief Shingwauk and reproduced by Henry Rowe Schoolcraft in his published notes illuminates the fact that the turtle is a serpent in an armored shell, thus firmly associating it with the subsurface realm and the mishibizhiw. Schoolcraft also notes the characteristics of the other figures in the drawing:

> Number 5 is the Misshibezhieu, or fabulous panther. The drawing shows a human head crowned with horns, the usual symbol of power, with the body and claws of a panther, and a mane. The name of the panther, Misshibezhieu, is a great lynx. The crosses upon the body denote night, and are supposed to indicate the time proper for the exercise of the powers it conveys. Number 6 is a representation of the same figure without a mane, and without crosses, and denotes the exercise of its powers by day-light. . . . [In] Number 11 he records the aid he received from the fabulous night panther—this panther, by the way, is generally located in the clouds.[16]

This quote reveals that there are many individual panthers with different roles rather than a generic class of "mishibizhiig," and that they play multiple roles across a blurred sky/subsurface boundary. Likewise, the plethora of thunderbird names demonstrates that the thunderbirds depicted on the bags—each with distinctive attributes such as colors, or number of dangling or ruffled feathers—are specific thunderbirds. Schoolcraft also notes that specific colors and stylistic elements (such as crosshatching) indicate different underwater panthers, so that a reader of the pictograph could identify the characters and their roles in relation to one another. They are, as Cory Willmott has described, aspects of the Anishinaabe cosmos as well as active "'persons' in a network of social relations."[17]

Elder Elizabeth Panamick also touches on the colors of panthers and the nature of specific panthers, as she expands on her above-quoted encounter:

Mii maa gii-bi-booniisemgag wi nihii, shkode.

That's where it landed that ... um, fire.

Mshibzhii dash wa.

And that's a lion.

Waaskone maaba mshibzhii, ni'ii, bmibzod niibaadbik.
Mmaandaa go gewii wi.

This lion is alight, um, when it flies in the night. That's so strange.

Nbiishing dash mshibzhii, mii yaawid aw—nbiishi-mshibzhii.

So, the lion from the water, that's what that is—a water lion.

Gewii-sh wa gidkamik mshibzhii eyaad, zaawzi gewii wa,
you know.

As for that lion that lives on land, that one's yellow, *you know.*[18]

Elder Panamick describes the ball of fire seen traversing the sky before landing upon the earth specifically as a *water lion.* She also specified that the lion that goes on land is yellow—distinct from the white mishibizhiw that appears in some retellings of the re-creation story—and from the panther with the copper tail.[19] These are not simply different takes on the same creature, but rather, evidence of a wide-ranging pantheon of spiritual beings, specific to certain places and roles. Diamond Jenness and Theresa Smith each have compiled lists of the various factions or types of thunderbirds (up to twelve, depending on the source), though they note that accounts naturally vary among communities.[20]

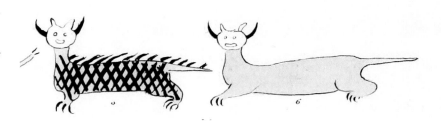

Illustration (details) by Seth Eastman for Henry R. Schoolcraft, *Historical and Statistical Information Respecting the History, Condition, and Prospects of the Indian Tribes of the United States*, (Philadelphia: Lippincott, Gambo, 1851), 1: 407, plate 57

Details of Eastman's illustration show (top) the night and daylight incarnations of the underwater panther and (below) the turtle as a serpent in an armored shell.

CONCLUSION

By looking to oral tradition, we have demonstrated two essential qualities of thunderbirds and panthers in Anishinaabe art: first, their role in a narrative-based, visual language, and second, their diversity and individuality as characters within the many-layered cosmos. Though the essential meta-narrative of thunderbird and underwater panther stories is the interaction between the upper and lower realms, this division implies no absolute categories, and neither does it limit their roles to generic expressions of good and evil. Like humans, they have alliances and enemies, internal politics, territorial feuds, and marriages. They are active agents embedded in lived Anishinaabe experience as natural phenomena, as part of the social framework of personal accounts and formal histories, and as visual motifs of power in artwork.

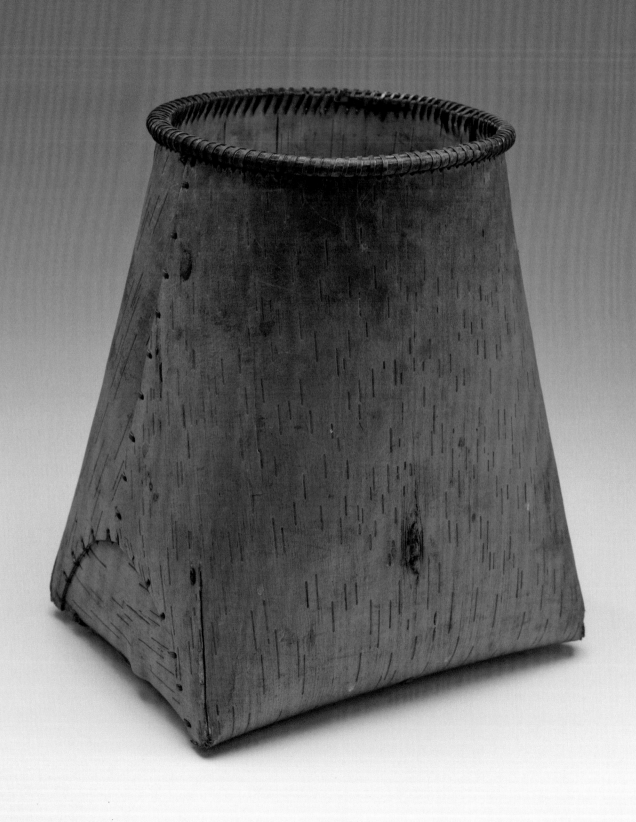

Things Anishinaabe

Art, Agency, and Exchange across Time

Anishinaabe things rarely reveal themselves fully at a glance. Some appear mundane but are understood by attentive and knowledgeable people to embody spiritual, "other than human," presence.[1] Some are made of local materials according to ancient forms and patterns, while others were manufactured elsewhere, entering Anishinaabe worlds through trade or diplomatic exchanges. Things that were primarily designed to serve practical purposes may possess a perfection of form and design that arrests the eye and pleases the hand; other things may strike the viewer first as objects of beauty but also have functional uses. These different kinds of Anishinaabe things, all framed by the Western category of "art," display qualities of taste and skill that result from their makers' consummate control over materials and creative engagement with inherited traditions. Thinking about the category of art cross-culturally, Franz Boas asked what gives aesthetic value to the things we perceive with our senses. His answer conveys this enlarged understanding of art: "When the technical treatment has attained a certain standard of excellence, when the control of the processes involved is such that certain typical forms are produced, we call the process an art, and however simple the forms may be, they may be judged from the point of view of formal perfection."[2]

More recently, scholars have become increasingly interested in how artfully made things forge and consolidate social relationships across time and space, and they have proposed a number of theories about how people and things act on each other. Literary scholar Bill Brown, for example, tells us that things harbor an essential mystery because they refuse to be completely described or limited by the names we give them.[3] Thinking about things as having this capacious yet elusive quality helps us under-

Anishinaabe maker unknown. Birchbark container, 1925–28. Collected in 1928 by Frederick Johnson at Parry Island Reserve, Lake Huron, Ontario. Birchbark and spruce root; 23.6 x 21 x 19.1 cm. National Museum of the American Indian 16/2565

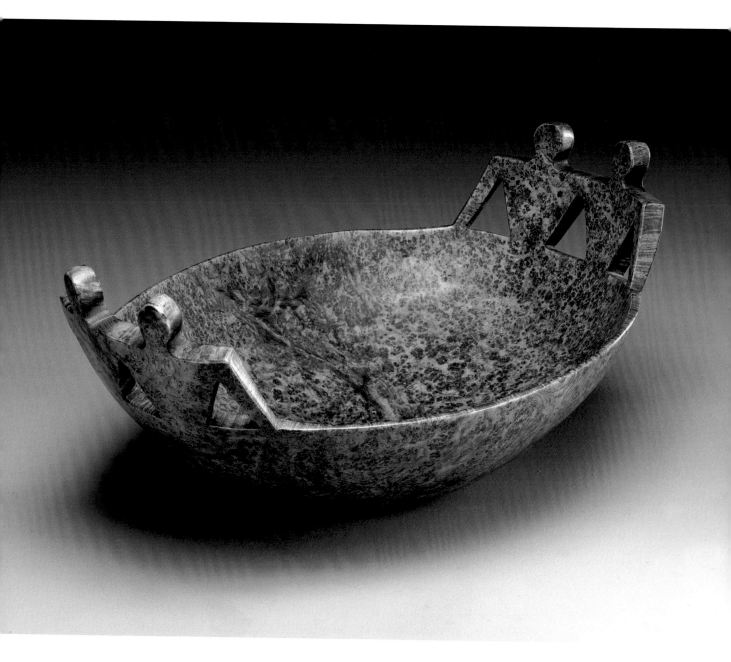

stand how they come to have different meanings for people in different places, times, and contexts. Anthropologist Alfred Gell has argued that works of art carry in their designs and forms the imprints of their makers' thoughts and imaginations. Once created and let loose in the world, the works are endowed with a power of agency that allows them to act autonomously on other people.[4] The concepts of materiality and spirit that Anishinaabeg have evolved over the centuries resonate with such theories, for the idea that agency is located not solely in human beings but is also

distributed across material, human, and animal realms is fundamental to traditional Anishinaabe thought. It informs, for example, traditions of gift giving in which valuable and beautiful things are presented to other beings, human and nonhuman, as a key strategy for establishing productive, reciprocal relationships. Things both make and carry history.

The vast majority of Anishinaabe things that have come down to us— including nearly all those made of organic materials such as cloth, wood, and bark—date to the four centuries during which the Anishinaabeg have been in contact with Europeans. They reflect exchanges not only with the newcomers but also those that took place among Indigenous artists of different nations long before and after European contact. Material exchanges of artful objects have anchored transformative flows of new ideas, tastes, and technologies that arose from these intercultural contacts. Indigenous peoples and Europeans collected each other's things, whether they saw them as attractive or repellant, curious or strange, beautiful or grotesque, even under the violent and oppressive conditions that accompanied colonial expansion. Anishinaabeg collected the pipe tomahawks, medals, brass kettles, trade cloth, beads, teapots, teacups, and laced hats and coats that Europeans offered in trade and as diplomatic gifts, while explorers, soldiers, colonial officials, settlers, and tourists collected the gifts, curiosities, and souvenirs offered by Anishinaabeg. In both cases, the wares reflected not only their makers' tastes and desires but also their perceptions of the tastes and desires of the recipients. Tracing the "social biographies" of Anishinaabe things over time, and the meanings and values they have had for users and viewers in different times and places, can yield insight into the complexity of Anishinaabe thought and the roles that artists and their works have played in the course of a rich and often difficult history.[5] In the absence of Indigenous-authored written descriptions of encounters between Anishinaabeg and outsiders, the material legacy of the past can serve as evidence of the thought worlds and artistic processes they stimulated.

It is impossible to do justice to these rich histories of art and exchange in a single short essay. Rather, I will suggest four visual strategies through which the distinctive world view and intellectual traditions of the Anishinaabeg were artfully inscribed in objects: ornamentation, spatial zoning, expressive ambiguity, and personification. The examples that illustrate these approaches evidence the agency of artists and the things they made in working out new challenges and stimuli in material forms, both historically and in recent years.

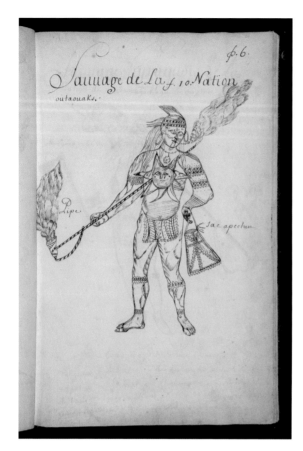

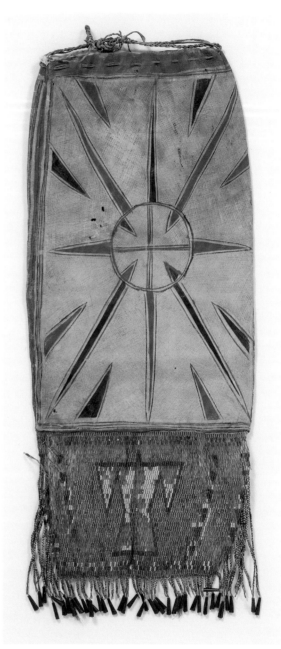

Attributed to Louis Nicholas. *Man of the Outaouak Nation,* 1674–1680. Brown ink on parchment. *Codex Canadensis,* Pl. VI, Fig. 10. Gilcrease Museum, Tulsa GM 4726.19

Anishinaabe maker unknown. Tobacco bag, 1800–1825. Painted leather, porcupine quills, brass cones; 51 x 21.5 x 1 cm. Musée du Quai Branly, Paris 78.1878.32.127

ORNAMENT: FROM GEOMETRIES OF POWER TO THE FLORAL AND THE PICTORIAL

By far the most extensive record of Anishinaabe artistry in the early years of European contact is contained in the *Codex Canadensis*, a compilation of drawings and written texts attributed to the Jesuit missionary Father Louis Nicholas. Between 1667 and 1670, Nicholas lived on the southwest shore of Lake Superior and in what is now central New York State, in missions that served Anishinaabe, Onkwehonwe, and other Native nations. Although he seems to have made his depictions of Indigenous people—

adorned with tattoos, body painting, and decorated clothing—and their canoes, weapons, and equipment around 1700, after his return to France, and to have based them in part on widely circulated engravings made from secondhand descriptions by François Du Creux, Nicholas added many dress accessories and other details that he had observed firsthand.[6] He also included an admiring description of the porcupine quill embroidery used by Great Lakes peoples: "First they dye it with various fruits and some herbs or roots, which give yellow, violet, black, reddish, and red, so that there is no scarlet as beautiful and brilliant as the one seen in the dyes of the women on very beautiful and rare works. . . . A thousand fine designs are seen on these objects. The natives esteem these works highly, and to tell the truth they are considered very fine in France."[7]

The Indigenous taste for rich ornaments that displayed "a thousand fine designs" is evident in Nicholas's drawings. In a number of them, men are shown holding a bag with a wide bottom that narrows in toward the top. This generic depiction probably represents a number of variations, one of which is a type of oblong hide bag with a panel of netted quillwork attached to the bottom that is found in French collections predating the British conquest of 1759. Although we tend to think of this type of bag as rectangular, because it is usually stored and photographed flat, when in use, with the drawstring threaded through the top edges pulled tight, it would have assumed the triangular, flat-bottomed shape depicted in many of the *Codex* images. The painted designs that ornament the hide surfaces of these bags and the images displayed on their suspended quillwork panels combine geometric designs with images of thunderbirds, other animals, and the sun. Both reference the great spiritual beings, or *manidoog* (singular: *manidoo)*, whose blessings of power Anishinaabeg sought through dreams and visionary experiences.[8] Nicholas labels one bag *sac appetun*, or tobacco bag, which would have been used to carry medicines (the indigenous plants smoked as offerings to the manidoog) or other important items having protective and ritual functions.

During the second half of the eighteenth century, the French, British, Americans, and allied Indigenous nations were engaged in a long struggle for control over eastern North America. With the end of the War of 1812, the strategic advantage of Aboriginal nations came to an end, and they lost their ability to resist the mounting pressure on their lands. The massive influx of settlers that followed forced the dispossession, removal, or restriction to small reserved lands of most Indigenous peoples in the Great Lakes region. It also brought a renewed wave of Christian missionization and pressure to assimilate to a new agricultural economy. Change was

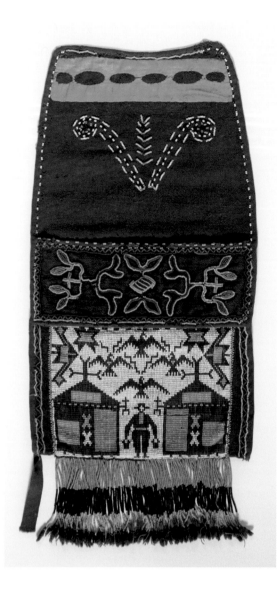

Potawatomi maker unknown. Shoulder bag pouch, ca. 1880. Wool cloth, cotton cloth, glass beads, wool twill tape, metal fasteners, mother-of-pearl buttons, thread. 50.1 x 23.5 x .5 cm. National Museum of the American Indian, Gift of Mrs. Thea Heye 10/6149

often rapid and traumatic, effectively ending a way of life that had lasted for millennia and been guided by wide-ranging seasonal movements over the land to hunt, gather, and trade. It also, inevitably, brought dramatic changes in visual art. By the end of the nineteenth century, it had become difficult for many Anishinaabe artists to acquire hides, quills, and other traditional materials. Missionaries and government agents made the public celebration of traditional ceremonies and rituals equally difficult. Until the renewal of Anishinaabe artistry initiated by Norval Morrisseau, Daphne Odjig, and other Woodland School artists in the 1950s and 1960s, the public display of images of the great manidoog incurred the disapproval not only of colonial bureaucrats and Christian authorities but also of many Anishinaabe converts. In response to these pressures, Anishinaabe artists replaced hide, quills, and paint with cloth, glass beads, and ribbon, and they invented new representational imagery to take the place of traditional geometric designs.

Despite these pressures, traditional knowledge, beliefs, and practices did not die out. Individuals continued ritual observances in private and were able to pass down oral traditions in other ways. Artists, for their part, found ways to reimagine traditional cosmologies using new floral and pictorial design vocabularies. A bag made toward the end of the nineteenth century, probably by a Potawatomi woman, is a good example. Although it is made of woolen cloth, thread, and glass beads, the elongated shape and the suspended panel of loom-woven beads are clearly derived from eighteenth-century painted hide bags. Even the gold ribbon sewn around the top edge, with its chain of oval cutouts, is suggestive of the slits through which a drawstring would have been threaded on the older bags. The floral designs embroidered on the bag, although innovative, incorporate the central, vertical axis of the world tree (*axis mundi*) and traditional double-curve motifs. Most strikingly, however, we can see in the figurative scene depicted on the bead-

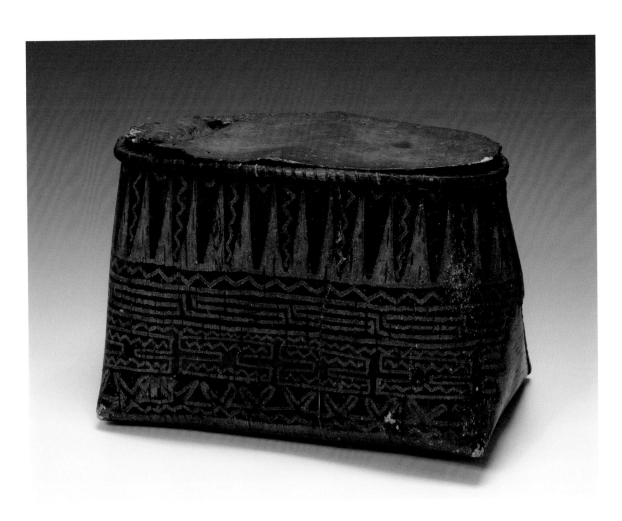

Anishinaabe maker unknown. Mokuk, ca. 1800. Birchbark, wood, spruce root, twine; 21 x 15.5 x 22 cm. Hood Museum of Art, Dartmouth College, Hanover, New Hampshire; Museum Purchase 163.66.15194

woven panel how the artist was negotiating the new agrarian economy and lifestyle. She shows us a man standing squarely between two Western-style, gable-roofed buildings. His brimmed hat, shirt, and trousers, and the buckets he holds in his hands, seem emblematic of the new farming life, yet above his head four thunderbirds hover protectively, emitting their lightning lines of power. The thick, lush fringe of beads that hangs down from this scene, strung so as to form the horizontal striped patterns found on the quill-wrapped thong fringes of earlier hide bags, participates in a fundamental Anishinaabe aesthetic of ornament that is expressive of the abundance, wealth, and beauty that blessings of power bring.

Parallel transitions from geometric to floral imagery occurred in clothing, dress accessories, and other genres. They can be seen with particular clarity in the ornamentation of the birchbark *mokuk*s that Anishinaabe women made in many sizes for cooking and for storing food and other goods. The earliest decorated examples that have survived, which date to the 1820s, have scraped designs related to the power lines that appear

Potawatomi maker unknown. Man's breechcloth panel, ca. 1890. Wool cloth, velveteen, cotton cloth, glass beads, metal beads, thread. 81.1 x 41.2 cm. National Museum of the American Indian 7/676

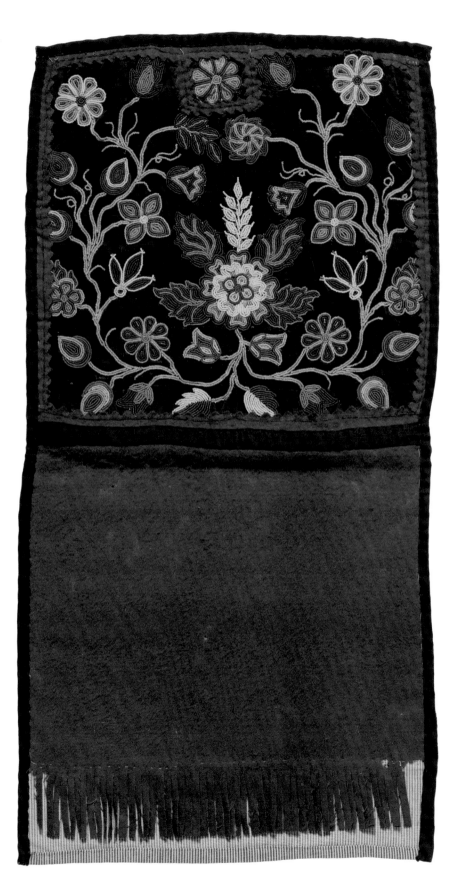

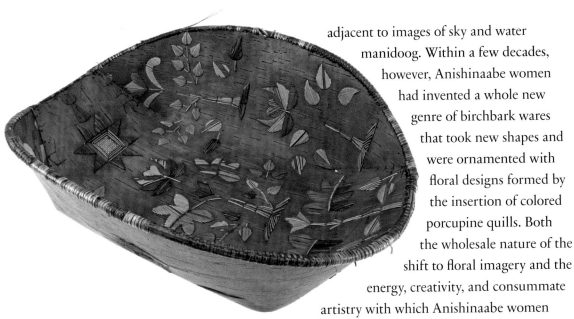

Anishinaabe (Saulteaux)
maker unknown. Quilled bark
dish, 1800–1825. Birchbark,
wood, spruce root, porcupine
quills, fiber, dyes; 14.8 x 35.5 x
44.6 cm. © McCord Museum
M2126

adjacent to images of sky and water manidoog. Within a few decades, however, Anishinaabe women had invented a whole new genre of birchbark wares that took new shapes and were ornamented with floral designs formed by the insertion of colored porcupine quills. Both the wholesale nature of the shift to floral imagery and the energy, creativity, and consummate artistry with which Anishinaabe women innovated within this new tradition are strong evidence that it continued to provide opportunities for women to express traditional knowledge and beliefs about the reciprocal relationships of human and plant worlds. During the 1930s, a renowned northern Ontario beadwork artist named Maggie talked with anthropologist Ruth Landes about the dream experiences that inspired her work. "She devotes herself incessantly to this form of embroidery, and receives visions in connection with it just as a man would receive visions in connection with hunting, divining, or war."[9] The adaptability of floral art to changing needs and issues is demonstrated by contemporary painter Christi Belcourt, who, inspired by her ancestors' floral beadwork, creates paintings that reference the interdependence of humans and the natural world, and the healing powers of plants in light of contemporary environmental concerns. "We humans, although each one different," she has written of one painting, "are of the same species and therefore we as individuals make up part of a whole. Our existence is [as] inexplicably interwoven with each other as it is with the existence of so many other species on this planet."[10]

SPACE: BALANCE, OPPOSITIONALITY, COMPLEMENTARITY

A second distinctive feature of Anishinaabe art across time is the division of compositional or surface space into clearly separated zones. These divisions model fundamental beliefs about the disposition and interrelationship of the forces that animate the cosmos. Cosmic space, in Anishinaabe and other shamanistic world views, is conceptually aligned along a central axis, sometimes imagined as a tree, that links an upper sky-world zone with earth and with an equivalent zone of power under the surface of

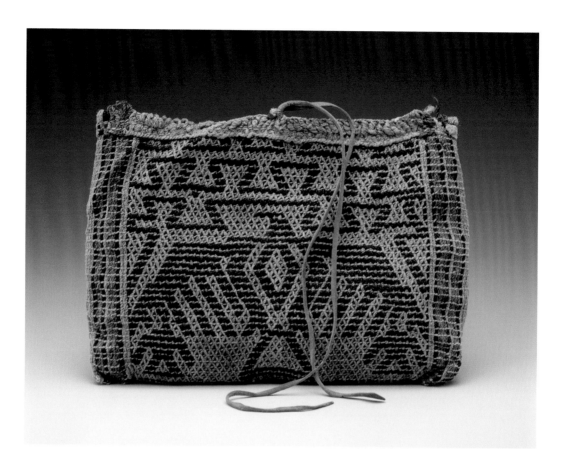

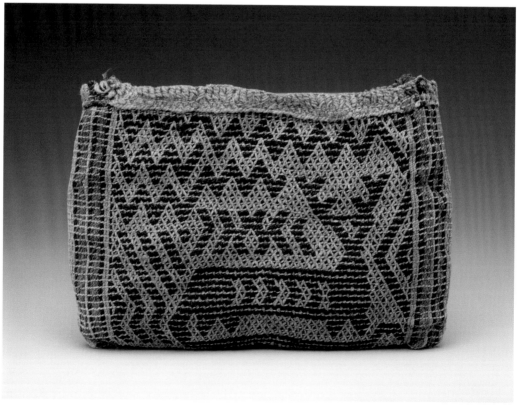

Before and after the Horizon

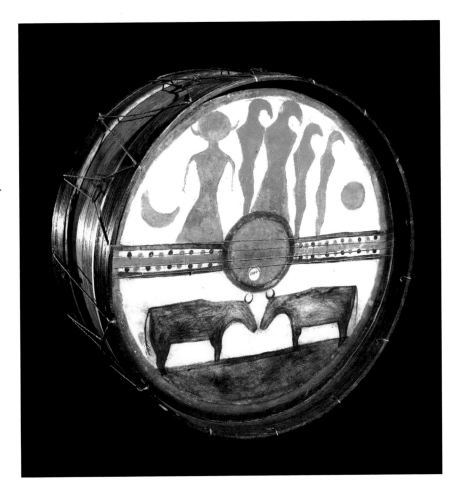

Meskwaki maker unknown. Medicine bundle container (front and back), ca. 1860. Twined nettlestalk fiber, wool yarn, buffalo hair (?), buckskin tie. Bag, 17.8 x 26.7 cm; tie, 39.4 cm. Detroit Institute of Arts (Chandler-Pohrt Collection), Founders Society Purchase 81.390

Anishinaabe maker unknown. Drum. British military drum, paint; 45 cm diam. Collected by Henry Christy in 1856, probably on Manitoulin Island, Ontario. British Museum

earth and water. These zones may be visually mapped as a kind of vertical layering. The three horizontal design fields of the late-nineteenth century Potawatomi bag discussed earlier reflect, for example, this characteristic way of structuring space. We might think of this tendency as a kind of spatial syntax that is deeply embedded in the Anishinaabe approach to composition, even when the item is not intended for ceremony or ritual. On some items, such as the finger-woven bags used to contain medicine bundles, the layering of space is modeled by the two surfaces of the bag, one side depicting sky-world thunderers, and the other the beings that reside under earth and water.

From an aerial rather than a vertical perspective, the cosmos is conceptualized as a circular space centered on the world axis. A principle of bilateral complementarity and balance is also integral to the Anishinaabe understanding of space. On a ceremonial drum, the spatial field may be divided in half to reflect the interdependent nature of fundamental binaries such as sky/earth, male/female, day/night, light/dark, good/evil or creation/destruction. The circle can also be subdivided into four equal

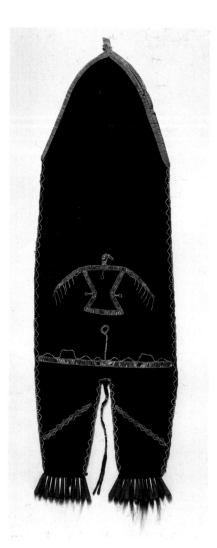
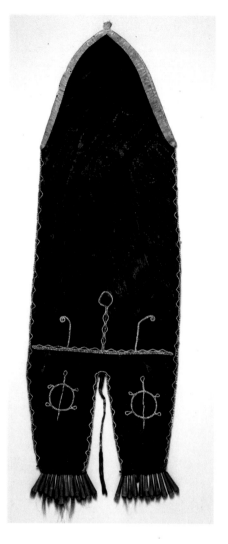

quarters which, in ritual contexts, may be associated with the four cardinal directions and the winds that bring the changes of seasons; they also may be keyed to particular colors. Today the four quarters also may be imagined as the four great continents (the Americas, Europe, Asia, and Africa) and their peoples brought into harmony and balance by the order of cosmic structure. From this perspective, the central axis linking the zones of upper, middle, and lower appears as a unifying central point or circle, which can be imagined as the world axis in cross section. Awareness of these cosmic structures enables an individual to center him- or herself in relation to the forces that animate the universe, to live in the world harmoniously, and to achieve the experiences of connection with the animating spiritual powers through which blessings of power are obtained. Art helps create this awareness and produce the ritually necessary experience of centeredness.

A dark brown hide bag with two tabs at the bottom and exquisitely rendered images of thunderbirds, turtles, and serpents on its two sides is typical of a small group of bags made in the Detroit/Ohio region around 1800. This example, which belonged to a prominent early settler of the Ohio territory named Return Jonathan Meigs, presents us with a fully three-dimensional spatial model. The thunderbird on one side locates us in the upper realm of power, while the turtles and serpents on the lower portion of the opposite side are beings of the waters. The delicate horizontal contour line beneath the thunderbird suggests a landscape of hills and valleys, while the wavy contour in the same place on the other side suggests water. The two spatial zones are linked by the circular motifs situated at the center of each composition, perhaps indicating a channel or passage through which human beings can shed the mundane world in dreams and visions and achieve spiritual encounters with these great beings. They are the "holes in the sky" noted by visionaries, the negative space of the metaphorical world tree.

As recounted in oral traditions, the manidoog are locked in an eternal struggle, creating opposing "charges" of energy in the space between them. In contrast to Christian cosmology, which assigns moral dimensions to the sky/heaven and the underworld/hell, Anishinaabe cosmology emphasizes the complementary nature of these two zones of power and the necessary balance of cosmic dualities, whether of thunderers and underwater beings, men and women, night and day, or youth and age. Artists expressed these principles of oppositionality and complementarity on a wide range of media and objects, the surfaces of which might be divided into contrasting color fields—for example, leggings that are pieced along the diagonal to create dramatic contrasts of red and black or green. To Europeans, accustomed to symmetry and regularity of composition, such approaches to space could seem strange. The German geographer and ethnologist Johann Kohl, for example, remarked in the 1850s, "Usually ... regular patterns do not suit the taste of the Indians. They like contrasts, and frequently divide the face into two halves, which undergo different treatment. One will be dark—say black or blue—but the other quite light, yellow, bright red, or white. One will be crossed by thick lines made by the five fingers, while the other is arabesqued with extremely fine lines produced by the aid of a brush."[11] Similarly, headbands, headdresses, and the straps of bandoliers and shoulder bags also may be divided into halves ornamented with contrasting designs that reference the oppositional powers of the manidoog. The general principles expressed by such spatial and coloristic designs remain current today, even when specific references and ritual uses are no longer known.

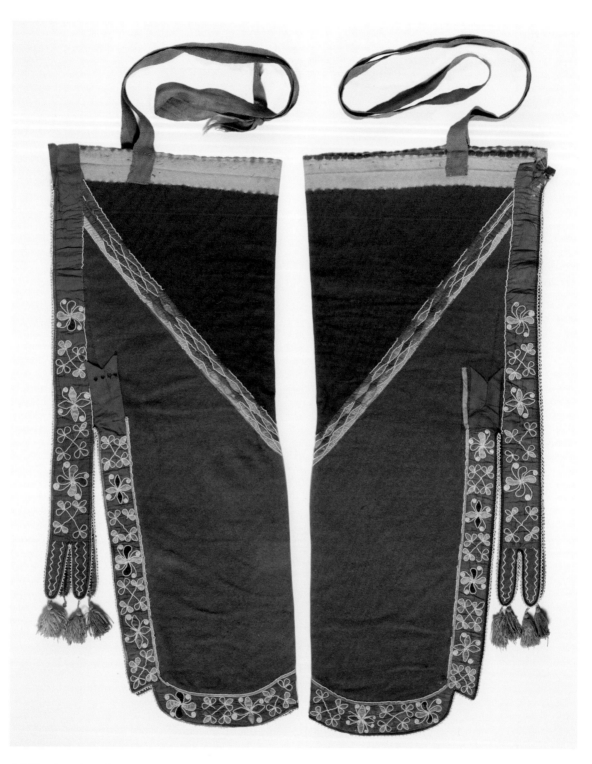

Anishinaabe maker unknown.
Man's leggings, 1840–1880.
Wool cloth, silk ribbon,
glass beads, wool twill tape,
wool yarn, thread; 70 x 30
cm. National Museum of the
American Indian 13/5900

EXPRESSIVE AMBIGUITY: ORDINARY AND EXTRAORDINARY SEEING

Prairie Potawatomi maker unknown. Mat and detail, 1900–1910. Bulrush, cordage, synthetic dyes; 302 x 154 cm. National Museum of the American Indian 2/7517

An odd thing sometimes happens when one spends time looking at one of the visual compositions just discussed. The energized lines that are embroidered on the surfaces adjacent to images of manidoog or that fill discrete zones in a tripartite spatial composition, the negative and positive spaces created by the precise contours and cutouts of a piece of ribbonwork appliqué, or the intricate designs woven into a rush mat suddenly move and shift before your eyes. Anishinaabe artists played optical tricks on viewers long before the op art movement of the 1960s, and they still have the power to make us suddenly unsure of what we are seeing. What is background and what is foreground? Are the scalloped lines references to the waves on the surface of water created by the agitations of the underwater being's long tail? Or are they the zigzag lightning lines emitted by the great thunderers?

This quality of intentional ambiguity is, then, a third characteristic of Anishinaabe art, and it seems to express the instability of mundane material forms that is a condition of their transformational capacity and their potential for revealing their inherent personhood. Visual ambiguity, in this sense, is a strategy for encouraging a deeper kind of looking, a preparedness for revelations of spiritual presence in the everyday. Knowledgeable Anishinaabeg have explained the importance of experience in determining the location of power and personhood in the world. Having

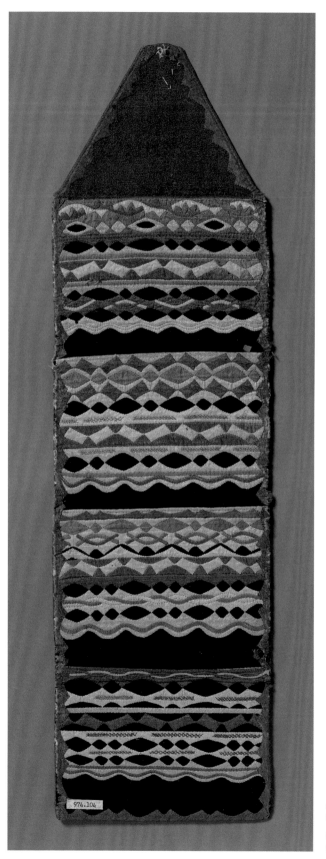

been told of the presence of thunderbirds in stones, the anthropologist Irving Hallowell recalled in a famous anecdote: "I once asked an old man: 'Are *all* the stones we see about us here alive?' He reflected a long while and then replied, 'No! But *some* are.'"[12] Such traditional knowledge was passed down to Norval Morrisseau during the 1940s and 1950s by his grandfather, Moses Nanokonagos, at a time when the Canadian government was trying to suppress it by removing children like Morrisseau from their elders to Christian residential schools. Armed with this knowledge, the young artist was able to interpret his own visionary experience and later depict his spiritual travels in easel paintings, an artistic medium that had not previously been used for the expression of traditional Anishinaabe beliefs.

Anishinaabe maker unknown. Wall pocket, ca. 1818. Wool, silk; 49.8 x 15 x .3 cm. Royal Ontario Museum 974.104

Anishinaabe maker unknown. Knife sheath, 1800–1809. Deerskin, sinew, natural vegetable fibers, porcupine quills, metal cones, thongs; 26.3 (excl. strap) x 5 cm. Jasper Grant Collection, National Museum of Ireland 1902:339

ANIMACY

On occasion, when studying historical Anishinaabe art, one comes across the unmistakable evidence of its maker's experience of spiritual presence in the materiality of a work of art. I will end this brief exploration of Anishinaabe things with two such examples. The first is a hide knife sheath that was collected by an Anglo-Irish army officer named Jasper Grant, who was stationed at Fort Malden, near Detroit, around 1805. In most ways this small sheath, which would have been tied to a belt or hung around the neck, is much like dozens of others that have come down to us from Anishinaabe makers of the eighteenth and early nineteenth centuries. In one respect, however, it is different, for on the upper portion its maker embroidered the unmistakable features of a living face. Whether the artist intended it to represent a being of animal or human form cannot be determined, but she—or the hunter or warrior for whom she made it—must certainly have intended this image to capture an empowering presence that enhanced his efficacy in the world.

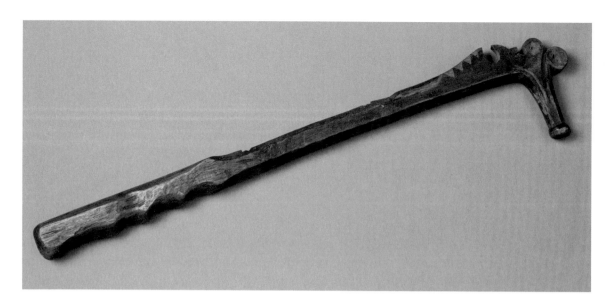

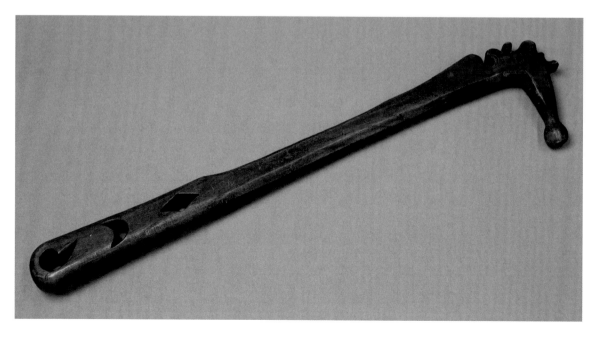

The second example is a drumstick, now in the Florida Museum of Natural History collection, that probably dates to the mid-nineteenth century. Its tip is carved in the shape of an underwater being with an elongated, maned head that resembles a horse, an animal introduced into the Great Lakes both by Europeans arriving from the east and Plains peoples from the west. The artist Paul Kane sketched a pipe carved in the same image in 1845 on Manitoulin Island, and a group of similar pipes can be identified in museum collections.[13] On the inner surface of the drumstick two faces are carved. As with the little knife sheath, these indications of the drumstick's personhood are easy to miss but evident to those who practice attentive looking and whose minds and senses are open to the kinds of presences that Anishinaabe things can embody and reveal. Recent research by Maureen Matthews and Roger Roulette in the same community where Hallowell worked in the 1930s has added to our understanding.[14] Through their analysis of the animate and inanimate linguistic terms that fluent Anishinaabe language speakers use to discuss ritual objects at different moments in their histories, they conclude that, as Hallowell's informant had earlier affirmed, animate presence in things is dependent on human interactions with other-than-human beings. Presence and personhood are, furthermore, transient rather than fixed, and apparent to human beings who remain open and aware. Meeting the evidence of successful past encounters that Anishinaabe artists have left us in their works underscores the power of things in the Anishinaabe world. At such moments the mystery and agency of things, and their ability to carry messages to us from unknown past artists, are at their most compelling.

The Anishinaabe Artistic Consciousness

The exhibition upon which this book is based began with David Penney and me. At the time, David was a curator and vice president of Exhibitions and Collections Strategies at the Detroit Institute of Arts (DIA), and I was the Fredrik S. Eaton Curator, Canadian Art, at the Art Gallery of Ontario (AGO). Relations between the two institutions had always been good: in many instances they shared fundamental ideas about reaching audiences,[1] and about how major metropolitan art institutions relate to Native American and First Nations visual histories.[2] Both museums had developed new approaches to incorporating the latter area, which had been long overlooked, into their activities and ethos.[3] The institutions also had in common geography, specifically the Great Lakes, as well as affiliations with Anishinaabe communities. While no exhibition can do justice to Anishinaabe art, history, and culture, this is the first of its scale to be undertaken. During the past few decades, however, similar identity-based exhibitions have focused on nationalist narratives in which art and material culture became the focal point.[4]

Contemporary art by those who identify as Anishinaabe (including the branch known as the Saulteaux) can be seen to have developed in response to the rapid decline of ancestral culture. This decline was owed largely to the colonizing forces of modernity (acculturation and assimilation)—especially between the 1880s and the 1950s. Artists such as Norval Morrisseau, George Morrison, Daphne Odjig, and Angus Trudeau had close connections to older generations, tenuous links that must be celebrated, since their recuperative visions launched generations of younger artists.

The succeeding generation was even more politically engaged—their demeanor was a provocation, demanding that the art world look and lis-

Arthur Shilling (Ojibway),
1941–1986. *Spiritual Change,*
(detail), 1980. Oil on Masonite;
142 x 90 cm. Thunder Bay Art
Gallery, The Helen E. Band
Collection 94.10.88

ten. For both of these earlier generations, issues of identity were the basis of articulation. In more recent decades, younger artists have appreciated the direction their predecessors established; they are much more secure, knowing who they are, so at times they can eschew participation in identity-based exhibitions such as this one.

The quagmire from which most Aboriginal peoples struggled to extricate themselves, both individually and in communities across Canada and the United States, is the backdrop against which the most interesting art was created. In this essay, I will examine works that are central to contemporary Anishinaabe art and by extension to the lives of Anishinaabeg today.

POSTWAR GENERATION

In the postwar period, Native American and Aboriginal communities across the continent have pushed to respond to the highly restrictive tenets of modernity, which governing authorities have imposed through policies related to controlling and assimilating all Indigenous peoples. These policies were relatively effective for generations, leading to an almost complete disconnect between past and present, and between tradition and enforced change. As a result, younger generations of Indigenous peoples have been asking questions about such disconnection, about the role of modernity in their lives, and about how to negotiate the future.

The Canadian artist with the greatest impact on the Anishinaabeg during the postwar period is undoubtedly Norval Morrisseau,[5] whose rise in the early 1960s gave significant voice to later generations of First Nations artists across the country. Morrisseau quickly became an iconic, tragicomic artist—a role frequently reinforced by the art world—and, to his credit, he was often more than happy to oblige. At the same time, his character and strategies were quite different because, while he may have been characterized as a primitive, he was also extremely serious about the decrepit conditions in which most Aboriginal peoples lived. In particular, he was deeply engaged in addressing the vacuum created by the systemic efforts of successive governments to neutralize any Indigenous cultural expression reminiscent of the old days.

In the United States, George Morrison[6] was leaving his own mark on art history—albeit without the same impact as Morrisseau. Both artists lived during an era when assimilationist policies in Canada and the United States were at their height. While Morrison spent time away from his ancestral community during his formative years as an artist, Morrisseau was still very much connected to his community.

Morrison spent the postwar years in New York, where he was actively engaged and fully absorbed in abstract expressionism as a student, artist, and professor. He returned to Minnesota in the heady days of the late 1960s and early 1970s, when Minneapolis was the center of action for the American Indian Movement (AIM). Like most young Native Americans, Morrison was no doubt feeling the zeitgeist of cultural revitalization, amidst regret for his own lack of connection with the past. These kinds of conflicting feelings produced wonderful and tantalizing fruit, such as his collage works.[7]

The early 1970s were pivotal for Morrison. Although a great deal of his work was of its time, when acceptance by mainstream modernists was critical, his pieces were without clichés or stereotypes. We are now, however, much more aware of the prominence of the idea of land in his work. It is from the land that he derived his singular Anishinaabe identity.

Morrisseau and Morrison grew up during a time when cultural identity was avoided. Enforced assimilation into the mainstream was the principal means of severing any bonds to traditional culture, considered anachronistic during an era focused entirely on change and the future. This was the new, modern age, in which there was no place for sentimental references to the past. The art world was motivated by an idea of modernism that celebrated a rejection of all things old. During this same time, however, the civil rights and feminist movements in the United States also were having a profound effect on Indigenous peoples across North America, awakening the body politic to a sense of pride in an identity based on history and culture, and to a need to recapture their lost voice.

Morrison was a modernist, whereas Morrisseau was often considered both a modernist and primitive[8]—perhaps a latter-day neoprimitivist. Morrison was a product of the New York school of abstract painting. Morrisseau, on the other hand, could not have lived further from the sophisticated realities of the modern world, especially when he was growing up and living in the far reaches of northern Ontario.

Although the two never met, both were formed by cultural connection. Morrison lived in Minneapolis amidst the ruckus of AIM and its quest for self-determination, along with the pressure brought to bear by authorities inclined to suppress such movements. Morrisseau lived quite a different reality—one that had at least two sides. On one side, Elizabeth McLuhan tells us, "[Morrisseau,] trained as a shaman, turned to images to revitalize an ailing Ojibwa culture."[9] The art world, however, saw a flamboyant character that no one since has come close to matching. Perhaps

Norval Morrisseau (Anishi-naabe), 1931 or 1932–2007. *The Light Is the Way,* 1979. Acrylic on canvas; 508.8 x 623.4 cm. Gift of Bernard Loates. McMichael Canadian Art Collection, 1988.1.A-.B

he is defined by this combination: a deep attachment to his traditional Anishinaabe heritage, which at the time appeared to be in decline; and his elevated stature in an art world where difference is not just accepted but encouraged.

One of Morrisseau's most significant works is called *The Light Is the Way* (1979), which addresses the upper and lower realms of Anishinaabe cosmology. The image divides up the space into two realms: an upper world inhabited by the thunderbird, shamans, and other beings; and the lower realm of earth, complete with the human and animal (fish, birds, and bears) dimension. I spoke with gallery owner Jack Pollock a few years after this work was completed.[10] He told me that Morrisseau had been going through a spiritual awakening with the Eckankar religious movement. His works around this time usually had subtle references to Eckankar, which teaches that the body can travel to other planes.

In *The Light Is the Way,* Morrisseau shows the central figure in the bottom panel as it is about to enter another plane in the upper half; the eye on

Daphne Odjig (Potawatomi), b. 1919. *Thunderbird Woman,* 1971. Mixed media on board; 93.7 x 63.2 cm. Aboriginal Affairs and Northern Development Canada Art Collection

top of the figure's head may signify a sense in the traveler that one can make such a transition with full consciousness. This painting was not the first of Morrisseau's works to be syncretically inspired; in fact, he had already done many works inspired by Christianity. It was Eckankar, however, that may have come closest to his traditional beliefs in shamanic travels. *The Light Is the Way* embodies this ethos, as well as the kind of *spiritus mundi* approach that Morrisseau took.

Morrisseau's greatest contribution to the art world was giving voice to Anishinaabe art and culture at a time when its tenuous links to the past were almost severed. Morrison and Morrisseau's contemporaries included Daphne Odjig and Patrick DesJarlait.

Daphne Odjig was interested in the modernist abstraction of the 1960s as well as in subjects that expressed her growing interest in Anishinaabe identity. Like Morrisseau and Morrison, she was of a generation that had

been made to feel ashamed of its heritage. As a result, for artists who were caught up less in the prevailing art styles and more in the sociocultural movements that were giving voice to the marginalized, work became a strong outlet.

Although not quite as well known as some of his contemporaries, Red Lake Ojibwe artist Patrick DesJarlait left behind a body of work that reflected the transition into the modern world of the Anishinaabeg and all Indigenous Americans. Eventually, DesJarlait established his own formal style, which was reminiscent of the great Colombian artist Fernando Botero, but the Mexican muralists were ultimately his true inspiration.

Morrisseau, Morrison, Odjig, and DesJarlait established an important footprint, not only for future generations of Anishinaabe artists but also for many other artists who identify strongly with their Indigenous ancestry. They began their careers in the 1950s, made solid commitments to their practices in the 1960s, and were universally embraced in the 1970s, when their individual artistic voices had become well established.

The next generation was a Janus-faced group that looked both forward to the future and back to history.

THE ANISHINAABE AS ARTISTS

Arthur Shilling, whose works eschewed Anishinaabe identity, was neither part of any avant-garde movement nor connected to the prevailing Morrisseau style. Instead, he owed more to earlier expressionist painters. His subject matter includes the everyday, landscapes, and portraits, although he was more devoted to self-portraits. For example, his self-portrait called *Spiritual Change* (1980) shows him in the act of painting while strange human and animal forms swirl around him. He shields his eyes with one hand while holding in the other either a crow or a raven, which appears to be dead. A snake emerges from behind him, its mouth open, ready to bite the artist.

Such depictions among Anishinaabe artists usually refer to and express reverence for the underwater panther, the *mishibizhiw*. The swirling figures appear to defer stylistically to Morrisseau, although they are Shilling's own interpretation of the spirit world. His color choices are always rich and vibrant. As the title implies, and the hallucinatory nature of the painting suggests, he is undergoing a spiritual change. The artist's wild hair is typical of Shilling's style, so it should not be interpreted otherwise.

I would argue that Indigenous artists ever since Morrisseau have been wrestling with fundamental questions of how to depict spirituality. As a

Arthur Shilling (Ojibway),
1941–1986. *Spiritual Change,*
1980. Oil on Masonite; 142 x
90 cm. Thunder Bay Art Gal-
lery, The Helen E. Band Col-
lection 94.10.88

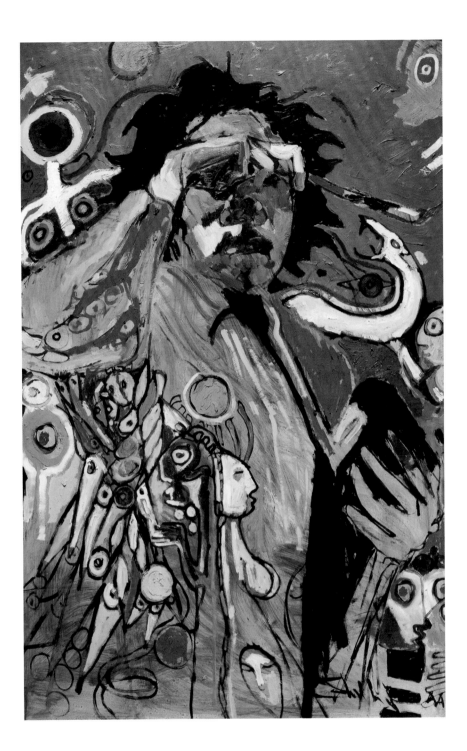

Plains Cree elder once said, however, as he and I were both looking at one of Morrisseau's works, "How can you know what the spirits look like?"[11] This elder was clearly the very kind who challenged Morrisseau in the first place, yet despite such criticisms artists saw the creative potential of visuals to suggest the possibility, and thus the presence, of such essences. Aside from some drawings, Shilling has produced few works like this, but *Spiritual Change* does raise some of the same fundamental ontological questions that artists and elders have continued to pose.

Carl Beam forms the nucleus of the generation that came of age in the 1980s. I often consider him an artist's artist, because of his proficiency with many types of media: paint, print, photography, and clay. Beam was interested in borrowing ideas not so much from his Anishinaabe tradition as from artists such as Robert Rauschenberg. As a result, he frequently combined photographs, printmaking, papermaking, and three-dimensional objects. He was a fierce critic, not only in his art but also in words, and he is often quoted.

A pivotal series of works created during the late 1980s and 1990s centered on his critique of Enlightenment ideology. While on a trip to New Mexico in 1989, Beam filmed a performance piece. In it, he is shirtless, walking toward the camera. He kneels down to dig a hole and then buries a ruler. He would reenact this ritual several times during the following years, resulting in several works on paper called *Burying the Ruler.*

For the next four years, Beam critiqued the Western philosophies that have come to represent the age of discovery (and conquest) of the New World. The ruler—symbolizing Protagoras's phrase "Man is the measure of all things" and its implied rationalist ideology—represented for Beam not only the opposite of Indigenous thought but also the European powers' systematic subjugation of all Indigenous peoples of the Americas. During the 1992 quincentennial celebrations of Columbus's arrival, Indigenous artists and thinkers across North America were fully engaged—ready to take a stand and pounce on the celebratory atmosphere. Demanding that their voices be heard and respected, they denounced the complete lack of awareness and understanding of the historical injustices done to Indigenous Americans. Beam's work during this time continued to pound away at this idea.

Robert Houle, an artist of equal standing who is also a curator, has enjoyed a long and successful career. Houle, like Morrison before him, drew his inspiration from abstract artists such as Kazimir Malevich, Piet Mondrian, Mark Rothko, Jackson Pollock, and Barnett Newman. It can

be said, however, that Houle was not strictly an abstract painter; instead, he adapted techniques from each of them. Unlike Morrison, who during the 1950s and 1960s was totally immersed in the world of the New York color field painters, Houle was almost two decades removed from their influences. He was even further removed from those of Malevich and Mondrian. What he developed from their influences was more in line with Anishinaabe principles.

While so many Anishinaabe artists reveled in using representational iconography to depict the Anishinaabe world, Houle sought a more conceptual approach. He was also quite specific in his sources, drawing on his Saulteaux heritage.[12] For example, *Parfleche for Norval Morrisseau* (1999) refers to a man he had known since the 1970s, and to the parfleche, a type of bag once used by nomadic cultures on the Plains, often to hold the sacred objects known as medicine bundles.

The conjunction of the parfleche and Morrisseau is not an accident. Houle had not only admired Malevich's art but also was taken with the idea espoused by Malevich and his contemporaries that art was essentially a spiritual activity. In the reference to Morrisseau—who, Houle felt, was the most spiritually expressive of artists—the idea for the painting came together.

Houle's series, *Premises for Self Rule* (1994), is a group of five large diptych paintings that comprise a history of the treaties negotiated and promises made between colonial governments and Aboriginal peoples. One work in the series, *Premises for Self Rule: The Royal Proclamation, 1763*,[13] focuses on what Aboriginal peoples have come to refer to as the Indian Magna Carta, a document that lays out relations between the British Crown and Aboriginal peoples, and refers to reserves for the first time.[14] *The Royal Proclamation, 1763* works like a diptych: the left is a large canvas painted in blues; the right features the basic text of the proclamation overlaid with a black-and-white photograph of a tipi village.

Houle purposely uses this type of photograph to suggest the problematic idea of "reserving" lands for people for whom owning land was ideologically and conceptually unknown. The photograph is of a nomadic people, who traveled across large expanses of the open prairies. Confinement to reserved lands was for them tantamount to life in prison "for as long as the grasses grow and the waters flow." Such classic colonial language has not, however, always worked against Aboriginal peoples; today the language of treaties has become big business. Aboriginal lawyers,

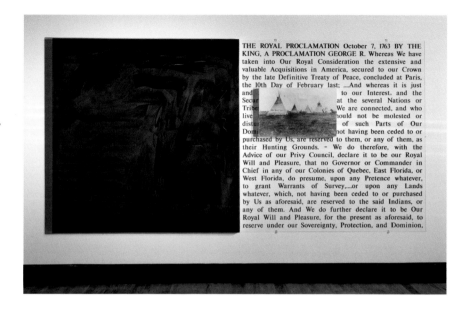

Robert Houle (Saulteaux), b. 1947. *Premises for Self Rule: The Royal Proclamation, 1763,* 1994. Oil, photo emulsion, laser-cut vinyl on Plexiglas, canvas; 152.4 x 304.8 cm. Collection of the Museum of Contemporary Canadian Art, Toronto, Canada

savvy leaders, and their advisors have invoked treaty provisions to make legal arguments that now put them in the driver's seat.

Houle's work is not always art for art's sake, for artists like him have had good reason to feel that the presence and position of Aboriginal/Anishinaabe/Saulteaux aesthetics will differ from Western aesthetics. Although *Premises for Self Rule* was produced when the political in mainstream art was coming to an end, for artists such as Houle the political still has currency as long as the art is good.

One artist who fits the identity of an artist—and who revels in making political statements, whether they are about the Catholic Church, big business, the federal government, pollution, the environment, stereotypes, or alcoholism—is Ron Noganosh. His humor and irony have been consistent. For example, *Shield for a Modern Warrior, or Concessions to Beads and Feathers in Indian Art* (1984), among his best-known works, features a quasi-artifact (perhaps an "artifake") based on the classic Plains shields used by warriors in battle. Feathers and medicines often hung on traditional shields—warriors generally depicted signs and symbols in a talismanic way.

Shield for a Modern Warrior, however, has a different function, albeit one that is no less personal, political, or psychological. Noganosh has indicated that this work was inspired after a night of heavy drinking. His personal circumstances are well documented: like many Native men, he grew up in a modern world with little or no opportunity and without a strong connection to tradition. He was expected to compete with everyone else yet lacked the tools and understanding to do so.

Ron Noganosh (Ojibway),
b. 1949. *Shield for a Modern Warrior, or Concessions to Beads and Feathers in Indian Art,* 1984. Mixed media on leather; 125 x 59 cm. Aboriginal Affairs and Northern Development Canada Art Collection
152522

Young people of his generation would socialize in places that were not always the most positive. For many, it was far easier to drown their concerns in alcohol. Noganosh has said that alcohol became the de facto shield for a modern Native person.[15] His personal test was to figure out strategies for putting down the shield. In itself, the shield looks rather sad—as does any shield on display in a museum, because the drama of its use is no longer evident. In *Shield for a Modern Warrior*, however, it acts as a new symbol for the modern warrior, which for Noganosh has double meaning. On the one hand it protects, and on the other it is a psychological crutch for the destitute and defeated. The shield in this work is, of course, useless, but like all art its value hinges on what it says to us.

Beam, Houle, and Noganosh—and to a lesser extent Shilling—were highly trained artists who well understood the politicized role of the artist, and of the Native artist, in the modern world. To the extent that they fretted about it, their work would endure in the years ahead. Each of them was as individualistic as any artist but also was connected to the Anishinaabe and contemporary art communities. Skilled, articulate, and travelling frequently, they saw new possibilities in the wider world.

On the other hand their counterparts who lived and worked within their communities were more concerned with maintaining Anishinaabe culture through their art and daily life. This group has been referred to as the Woodland School, partly because of where they lived and partly owing to the influential work of Norval Morrisseau. Many can be included in this school.

THE ARTISTS AS ANISHINAABEG

In 1984, the Art Gallery of Ontario presented an exhibition proclaiming Morrisseau's influence. The curator, Elizabeth McLuhan, wrote: "The achievement of having invented and refined the style belongs to Morrisseau. The emerging younger artists are the beneficiaries of the legacy and have painted exclusively in this style."[16] She goes on to point out artists such as Daphne Odjig, Carl Ray, Joshim Kakegamic, Roy Thomas, Saul Williams, and Blake Debassige. These are the artists who have been variously referred to as the Woodland School or the Legend Painters, both rather unfortunate designations that locked them into tight frames that they all found difficult to shake. The first term—*woodland*—is an anthropological reference connoting artists living in the Ontario woodlands, thus shaping assumptions about them. One might think, for example, that their total way of life is conditioned by tradition without regard for their inter-

connectedness to the larger world. The second term—*legend painters*—is
also misleading: not all the artists confined themselves to painting ancient
legends. In fact, their work addressed many other issues. While any phrase
is problematic, the influence of Morrisseau is unquestionable.

Morrisseau's sway went beyond the Anishinaabeg—his early connec-
tions were with Cree artists such as Carl Ray and Joshim Kakegamic, who
hailed from around Thunder Bay. Morrisseau lived in his wife's commu-
nity, where he met Ray and Kakegamic, so the connection was established
early on. Kakegamic became Morrisseau's brother-in-law, and Carl Ray
helped Morrisseau paint a mural for the Indians of Canada Pavilion at
Expo 67 in Montreal.

Ray and Kakegamic took from Morrisseau not only a form-line style
but also a sense of pride in their Aboriginal identity. The 1970s were a
time of opportunity for many Aboriginal artists—especially those who
had been lumped under any of the preceding clumsy designations. In
addition, art-producing centers such as Winnipeg and Toronto now
were accessible. Across the country, sales of Aboriginal art dramatically
increased. The next generation also was beginning to establish itself
through new marketing techniques.

During this time the Manitoulin Island community M'Chigeeng First
Nation, where Carl Beam was born, gave rise to a number of artists,

including Blake Debassige. During his wonderful though fairly quiet career, Debassige's paintings have been much admired for their sureness of application and inventiveness with form lines. Employing this now-classic approach, Debassige thoroughly works out his ideas across the entire canvas. Unlike others, who place a central image or images against a stark or monochromatic background, Debassige manages to build his composition out of the background. While a number of his peers may use the surface as if an image had been abstracted from elsewhere and placed on a square canvas, Debassige carefully works out a figure-ground relationship. For example, *One Who Lives under the Water* (ca. 1978) features an ancient story that Morrisseau frequently depicted. Debassige, however, goes beyond showing just the figure of the *mishibizhiw*, the underwater spirit: by including two boats overturned by a pair of mishibizhiig, the artist implores canoeists to be safe in stormy waters. If the boaters do not heed the signs, disaster may ensue. Clearly, this is a kind of allegorical painting in which the mishibizhiw is a symbol of death. The third canoe in the background may be next in line, or it could be spared. Either way, its occupants now know the danger. To all the canoeists in the story, weather is a matter of life and death.

Carl Beam's work has a political edge, reflecting a time when cultural politics seems to have been on everyone's mind—especially on those of artists who had felt historically marginalized. The 1980s fueled such artists, although using art politically goes further back—in the 1960s and 1970s, for example, the American artist Fritz Scholder created works that would significantly influence future generations. But during the 1980s, on both sides of the border, Anishinaabe artists such as David P. Bradley, Rebecca Belmore, and Frank Big Bear Jr. traveled farther along the political route than had their predecessors.[17]

THE POLITICAL MARGINS

During the 1980s culture and identity politics in the art world were at their height for those who felt underrepresented in mainstream exhibitions and collections. At the close of the 1980s, two important books were released that summarized the decade. The first was Lucy Lippard's wide-ranging and inclusive *Mixed Blessings: New Art in a Multicultural America* (1990), in which she says: "The art reproduced [in this book] demonstrates the ways in which cultures see themselves and others; it represents the acts of claiming turf and crossing boundaries *now* [italics hers], in 1990, two years before the five hundredth anniversary of Columbus's acciden-

Blake Debassige (Ojibwa), b. 1956. *One Who Lives under the Water*, ca. 1978. Acrylic on canvas; 127 x 96.5 cm. Royal Ontario Museum 978.338.1

tal invasion of the Americas."[18] Another book that year was *Out There: Marginalization and Contemporary Cultures*, in the foreword of which Marcia Tucker writes: "[*Out There*] is a collection of essays that explore and ultimately, we hope, deconstruct the problematic binary notions of center and periphery, inclusion and exclusion, majority and minority, as they operate in artistic and social practice."[19] Within this zeitgeist, many Native American artists developed their practices.

David P. Bradley, formerly of Minnesota, has been a local fixture in Santa Fe since attending art school there in the 1980s. He is of the genera-

David P. Bradley (Minnesota Chippewa), b. 1954. *Pow-wow Princess in the Process of Acculturation*, 1990. Acrylic on canvas; 121.9 x 91.4 cm. Permanent collection of the Plains Art Museum, Fargo, North Dakota 1992.001.0001

tion whose use of ironic codes cuts two ways: his messages speak for and against both Native and non-Native audiences. He is far more removed than most Anishinaabe artists from the Great Lakes. While other artists such as Carl Beam have made political references in oblique ways, Bradley's work combines humor, irony, and parody with frequent pop-culture references. While much of his art addresses southwestern themes, one piece—*Pow-wow Princess in the Process of Acculturation* (1990)—includes references to art history and his beloved Great Lakes.

Miss Indian USA, in *Pow-wow Princess*, is a clear take on the *Mona Lisa*. In this work, Bradley dredges art-historical sources for inspiration—and to test his point. Although paintings such as this one may appear to be one-liners, they do have redeeming artistic qualities.

Fitting into the spirit of its times, Bradley's work criticizes. His aim is to tear open new wounds that cannot be ignored. *Pow-wow Princess* may appear to be directed at all young Native American women who aspire to be a pageant queen or princess, or to be immortalized as the Mona Lisa, but the painting is much more about the pop-culture objectification of Native women as either princesses or the "s" word.[20]

Miss Indian USA is itself an idea that puts women on a pedestal through the sheer callousness of the machinery that invests in such wrong-headed stereotypes. As for the *Mona Lisa,* pop culture has eviscerated its context to such an extent that the painting's original meaning has been largely lost to all but experts. In Bradley's work, as in bad twentieth-century Western movies, numerous references seem to collide with one another to such a degree that they become comical and nonsensical. This is the strength of his art.

Frank Big Bear Jr. also is critically engaged with issues surrounding the stereotypes that have plagued American Indians and with the general malaise of the Indigenous body politic in response to modernity and all its consequences. Unable to make a living as a full-time artist, Big Bear drove a taxi for more than thirty years—an experience from which much of his content derives. The influences of George Morrison, and of cubism and surrealism, are evident in the way he fractures space and breaks up figures into many tiny forms (both abstract and representational).

Big Bear takes full advantage of a vibrant color palette, which, along with the fragmented forms, makes each drawing or painting quite different from the next. *Chemical Man in a Toxic World* (1989–90) is like a visual dictionary of images from Big Bear's world—each as important as the next, existing in close relation to one another. A man is seated at a table,

drinking and smoking, with "Live Hard, Die Young" tattooed on his arm. On the opposite side is a young woman with white and blue wavy lines running across her face.

The range of images is diverse, and some do appear nonsensical—as if, during thirty years of driving a cab, he has seen it all. Unlike the experience of viewing Bradley's equally brilliantly colored, Santa Fe–inspired works—which are fairly representational and also filled with many references—you do not know where to begin looking at Big Bear's work. Perhaps that is its beauty. We want to pin his influence on some well-known historical personage, yet throughout years of work he has been undeniably consistent. Each image evokes a thought that, when juxtaposed against another image, brings forth another thought, and so on, until we eventually lose our original reading.

One artist whose works have been consistently political, yet who has now become part of the mainstream, is performance artist Rebecca Belmore. Her early works were performed in and around Thunder Bay, near where she was raised. Belmore is the first of a new generation of Anishinaabe women to use art to call attention to feminist perspectives.[21] Early in her career, she developed a highly effective persona named High Tech Teepee Trauma Mama, taking a trickster-style approach to addressing sexism, racism, and misogyny. While audiences in the United States were enjoying the performance works of James Luna, Belmore became Canada's preeminent performance artist, and in 2005 she was the second First Nations artist to be chosen to represent Canada at the world's most prestigious exhibition, the Venice Biennale.[22] Ironic humor and political theater best describe her work.

Belmore's *Rising to the Occasion* (1991; not illustrated) was originally conceived in July 1987, when Prince Andrew and Sarah Ferguson, the Duke and Duchess of York, traveled to Thunder Bay to participate in a reenactment. They were taken up Kaministiquia River, put into a birch-bark canoe, and paddled down to Old Fort William, where a large crowd greeted them. The pageantry of replaying British history in Canada prompted a group of local artists to organize a performance called *Twelve Angry Crinolines*, which included *Rising to the Occasion*, a dress that Belmore wore. A mix of historical allusions to First Nation/British relations, the dress's bustle forms a "beaver-house" that includes various references to a British monarchy caught in the dam of history. The fine Victorian outfit, fabricated with embroidered velvet and satin, is adorned with a buckskin fringe, beadwork, and two porcelain saucers, that serve as breastplates.

Frank Big Bear Jr. (Chippewa), b. 1953. *Chemical Man in a Toxic World*, 1989–90. Colored pencil on paper; 228.6 x 111.8 cm. Collection Walker Art Center, Minneapolis; T. B. Walker Acquisition Fund, 1991, 1991.10.1-.3

Belmore's nimble use of the trappings of both Aboriginal and European cultures (a frequent tactic in her work) challenges the stereotypes of both. She says:

> We were nowhere near Old Fort William, so we had a silent parade. We went up into an artist-run center, which is called Definitely Superior, and had a Mad Tea party. I made *Rising to the Occasion,* since I was thinking about the idea of the royal family coming to a reconstructed, historic, fur-trading fort, reenacting their history. So I wondered what I'd make for this occasion. I remembered our dinnerware that we had when I was a child. It had roses on it. It was probably from England. You know I grew up with those plates. I never thought about where they come from, until I was making this dress. So I guess it was a natural thing. I grew up with those dishes, and I grew up looking at the beadwork.[23]

Performance has got to be one of the most exhilarating forms of art for audiences—and exhausting for the performer. While most performances require an audience, some artists undertake performances alone in the quiet of nature and record them for posterity or public viewing at a later time. Belmore has frequently pointed out the positive aspects of performing before Native audiences, as they usually understand and relate to her ideas. Now, however, she is not as choosy, and her following has steadily increased. Few Anishinaabe performance artists have followed in her footsteps, although Maria Hupfield recently has done so. Belmore has had more influence on other First Nations artists across Canada, such as Lori Blondeau and Skeena Reese.

A NEW GENERATION

A more recent generation of artists draws on many sources and types of media. Although most of them have been around since the 1990s, many have come into their own only recently. As for so many artists of Anishinaabe heritage, tradition no longer means continuity of skill with a particular material; rather, it lies in how essential ideas are expressed through new materials or visualizations.

Although Christi Belcourt identifies herself as Michif/Métis, she has nonetheless been using paint to depict plants in the way past Anishinaabe artists represented them using beadwork. She understands that Indigenous peoples in the past needed, for survival, to know how the plant and animal worlds functioned. Plants could be life threatening, so an intimate

knowledge of their various properties as food, medicines, and other useful materials was essential. This knowledge extended to ways of representing them—for example, on clothing and containers in the form of colorful floral patterns on a dark background. This understanding of plants was Belcourt's inspiration for studying her Métis heritage, in which she found such voluminous examples of floral patterning that for her it was an obvious choice of artistic expression.

Belcourt's large canvases feature formal floral patterns spreading in various directions. They are not wallpaper or illustrations; rather, they are complex stories of the plants Belcourt has been studying for the past decade. Drawing upon traditional Métis and Anishinaabe visual texts, she has, as her predecessors did, created stories for each work. In *So Much Depends upon Who Holds the Shovel* (2008; illustrated on page 25), we see a complex arrangement featuring dozens of varieties of plants, all interconnected, all living together where there is no concept of weeds—which is to say that no plant is out of place. She begins at the roots, which for her represent history and ancestry, and proceeds to the plants themselves—including strawberries, cedar, and wild rice, which are likely to be used in ceremonies. She uses a dot style of painting, reminiscent of beadwork. The irony of the title is that it alludes to human responsibility for the future of our natural world, especially in an age of global climate change.

Since the late 1990s, Bonnie Devine[24] has centered her work on issues of land, history, and decolonization. Born in Toronto, she is a member of the Serpent River First Nation, where uranium-mining issues have become a central concern for local citizens as well as environmental groups. This has prompted Devine to consider not only the consequences of uranium mining but also the extent to which art, by synthesizing various local stories, can arrive at something beyond mere partisan statements.

Many First Nations artists who draw inspiration from traditional principles see the question of land, in a contemporary sense, as central to their practice. This is far more nuanced than, say, the land artists of the 1960s, who were out on the land creating sometimes-ephemeral works using local materials. Sometimes their outdoor spaces became unconventional galleries.

Devine and other artists focus on the revitalizing stories that come out of their history. This is seen as a way of combating the enforced acculturation processes of the twentieth century, which attempted to wipe out collective cultural memory. In *Letter to William* (2008), the reference is to William Johnson and to issues surrounding history and origin stories. The diptych begins with a large, abstract close-up of a rock, on which she writes: "I have

Bonnie Devine (Ojibwa),
b. 1952. *Letter to William*, 2008.
Giclée print, graphite, and
cotton thread on paper and
canvas; 61 x 182.9 cm. Nation-
al Museum of the American
Indian 26/9026

come to listen, believing the rock is filled with stories. I have come to read, believing the rock is a text." On the other side, she has superimposed imagined glyphs over the text.

The point of these works is for us to understand two types of text. We might not, however, understand either of them, as differing epistemologies form the basis of each reading. Artists/thinkers such as Devine represent a new type of Anishinaabe individual, who asks new questions so that others may be encouraged to remember, or to shake off the mental cobwebs that provide the keys to this new (old) understanding.

Similarly, we read Nadia Myre's art through text. Her *Indian Act* (2002) asks us not to read or understand the basis of an archaic piece of legislation that has become a symbol of control over all Aboriginal peoples, but rather to consider its consequences. The entire work, which reads like Morse code across the page, consists of fifty-six beaded pages created with the assistance of more than 230 people; in some parts of the work, pages of text are interspersed with the beads.

Like Devine's diptych, Myre's work suggests two readings. Her *Indian Act* is an iconoclastic action taken upon an object that has come to symbolize a policy of control rather than a treaty agreement between nations. Myre's use of beads is telling, as it has become synonymous with traditional First Nations art. Readily accepted and incorporated into the culture after European contact, beadwork historically represented cultural texts. Now, it takes on new meanings,[25] which are different for each artist. In *Indian Act*, beadwork is used as an important signifier because of its political content. Unfortunately, the only constant here is the original text itself, the Indian Act.

While beads are now considered a traditional medium, the gifted Anishinaabe artist Michael Belmore has returned to the even more ancient medium of copper, which was considered sacred by his ancestors. Archaeologists have discovered copper objects near the western end of Lake Superior, at Isle Royale (a territory now a part of the United States). Used for several thousand years, copper was cold-hammered into knives,

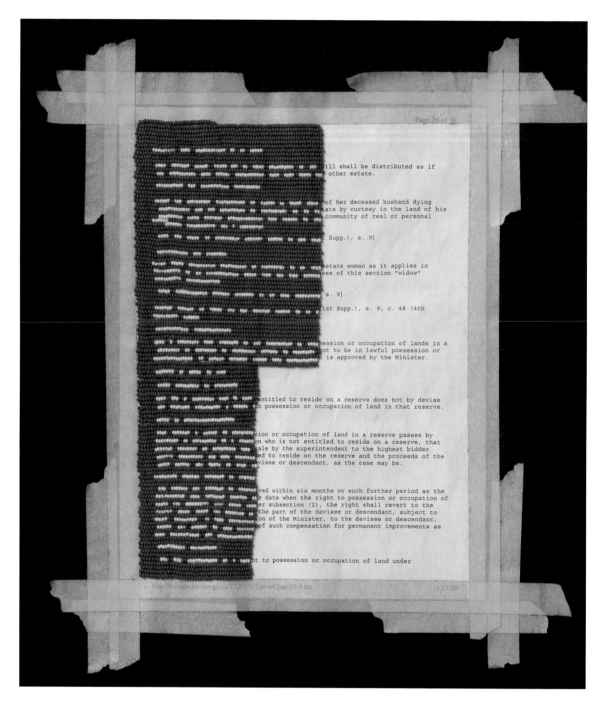

Nadia Myre (Anishinaabe),
b. 1974. *Indian Act,* 2000–03.
Glass beads, Stroud cloth,
acid-free paper, masking
tape, thread (pages 26 and
7 of a 56-page work); each
page, 20.3 x 30.5 cm. National
Museum of the American
Indian 26/7723

Gerald McMaster

Michael Belmore (Ojibway),
b. 1971. *Shorelines*, 2006. Hammered copper; 213.4 x 182.9
cm. National Museum of the
American Indian 26/8459

Michael Belmore (Ojibway), b. 1971. *Shorelines* (detail showing the Great Lakes), 2006. Hammered copper; 213.4 x 182.9 cm. National Museum of the American Indian 26/8459

hammers, bracelets, fishhooks, harpoons, and scrapers. Because of its unusual characteristics and availability, copper was often considered a sacred material with significant meaning, in addition to being valued for its practical uses. There is also some indication that copper was associated with the mishibizhiig (underwater panthers), whose horns are said by locals to be made of copper.

Belmore's *Shorelines* (2006) consists of two large pieces of hammered copper depicting the entire continent of North America. The piece ripples, wavelike, when propped against a wall. Shorelines are where water and land meet—such meeting points are not oppositional, but rather suggest the complementarity of the two elements, which has an interesting associative quality. Shorelines were the meeting points for Native peoples, Europeans, and Asians. Yet, the shoreline also is an interstitial zone where, for example, fresh and salt water mix.

This idea can be extended to encompass the meeting of the two great spiritual powers, *animikiig* (thunderbirds) and *mishibizhiig* (underwater panthers), whose eternal struggle has been captured in Anishinaabe art from historical to contemporary times. Although Belmore has reproduced

Wally Dion (Saulteaux),
b. 1976. *Thunderbird*, 2008.
Circuit boards, plywood,
acrylic paint; 121.2 x 296 x 9.4
cm. Collection of the MacK-
enzie Art Gallery, purchased
with the financial support of
the Canada Council for the
Arts Acquisition Assistance
Program

the shorelines of the continent, the vast shoreline of the Great Lakes is
equally powerful and filled with personal and shared stories. We might
remember that George Morrison eventually left the cities of New York
and Minneapolis to spend the last years of his life on the shoreline of Lake
Superior, which was the thematic basis of so much of his art.

This new generation of artists also is using found materials in surpris-
ing ways. Wally Dion and Maria Hupfield each realize that ancient ideas
can find renewed articulation in unusual materials. Hupfield, for example,
refashions traditional forms, using paper in place of birchbark, the tradi-
tional Anishinaabe staple.

Wally Dion uses parts from discarded computers, seeing the dual
nature of electricity, a timeless characteristic of lightning that is also used
to power up modern-day appliances. Dion's *Thunderbird* (2008) has quickly
become an iconic work because of its associative meaning. Like many
great works of art—and in particular those that are expressed from a First
Nations perspective—the power is in the idea. In this instance the ancient
signifier is the thunderbird; in Hupfield's case, it is moccasins and baskets.
Whatever the material, it is the idea that is potent. If an artist conjoins an
unusual material with an idea that in some way produces an unexpected
(or signified) meaning, then a work becomes even more successful. Play-
ing out this notion, for example, is the wide range of materials used to
signify the thunderbird in works throughout this book.

Maria Hupfield (Anishinaabe, Wasauksing First Nation), b. 1975. Basket, 2000. Paper; 11 x 18 x 33 cm. Aboriginal Affairs and Northern Development Canada Art Collection 407655

Andrea Carlson takes as her inspiration the Anishinaabe culture hero Nenaboozhoo for the cycle of stories she calls *Aadizookaanag (Spirits)* (2005), meaning traditional or sacred narratives.[26] For many, this cultural hero is a kind of trickster; more importantly, however, Nenaboozhoo is the spirit most vital to Anishinaabe epistemology, for it is through the Nenaboozhoo narratives that we know how everything came into existence.

Star Wallowing Bull, the son of Frank Big Bear, has an aesthetic that is quite similar to that of his father in that his canvases are crammed with visual references to pop and Native American cultures. But it was perhaps his chance meeting in May 2005 with American icon James Rosenquist in Fargo, North Dakota,[27] that inspired him to continue in the arts after several years of soul searching and alcohol-related issues.

Unlike his father, who draws exclusively from memory, Wallowing Bull uses in *Ojibwe Service* (2008) pop-culture images, often verbatim, and lays

Star Wallowing Bull (Minnesota Chippewa Tribe, White Earth Nation), b. 1973. *Ojibwe Service*, 2008. Colored pencil on paper. Collection of the Bockley Gallery, Minneapolis, Minnesota

them over the surface in a Rosenquistian way, though his canvases are not as large. The work appropriates hood ornaments from General Motors Pontiac, Ford Mustang, and Mercury Cougar cars as well as Shell Oil and 76 gas logos, light bulbs, skulls, a duck, a rooster, a frog, insects, plants, traditional Anishinaabe patterns, and the artist's own Indian-head logo surrounded by the words *Ojibwe service*.

Like Rosenquist, Wallowing Bull is attracted to mass media and its impact on contemporary life. In his work, we see the conjunction of mass media and Native American life. Native viewers are asked to question our evolving roles not only as consumers but also as people identified with the brands and lifestyles these products represent. With Native communities so impoverished, it becomes somewhat humiliating to face constant messages to be good corporate consumers.

A number of photo-based artists such as Keesic Douglas are finding new ways to express Anishinaabe life. His Lifestyles series (2007) poses a young, urban Indigenous couple in their home, much in the way that fashion magazines prescribe a new, invigorated life. With all their worldly

Keesic Douglas (Ojibway), b. 1973. *Lifestyles*, 2007. Chromogenic print; 76.2 x 76.2 cm. Collection of Keesic Douglas

goods, this young couple is capable of living a good and happy life, combining their Indigenous identity with all that modern living and consumerist culture can offer.

Frank Shebageget's *Beavers* (2003) installation uses hundreds of models of the iconic de Havilland DHC-2 Beaver floatplane to suggest the importance of air transport to a country as vast, inaccessible, and sparsely populated as Canada. Most of the population, which is concentrated along the border with the United States, has relatively infrequent contact with Indigenous peoples. Aboriginal peoples, on the other hand, still live throughout the country, many in communities that are often accessible only by plane or boat. *Beavers* shows the connection and relationship between urban and

Frank Shebageget (Anish-nabe), b. 1972. *Beavers*, 2003. Basswood and metal; 142.2 x 243.8 x 152.4 cm. Collection of the Ottawa Art Gallery: purchased with the support of the Canada Council for the Arts Acquisition Assistance Program, Glen Bloom, and OAG's Acquisition Endowment Fund, 2005

rural areas. What we do not know from this work are the technology's positive and negative effects. Suffice it to say, for Indigenous communities, planes are often the only lifeline, and they welcome it.

Shebageget's installation appears to be a swarm of Beavers, which is antithetical to how beavers actually live, since the creature's communities usually are small. Perhaps the most significant message of Shebageget's work is that both the plane and the animal have affected the landscape. Although the original model of the Beaver was discontinued more than forty years ago, many are still being flown in northern Canada.

CONCLUSION

The objectification of cultural identity through the arts became key to Anishinaabe consciousness. It has been repeatedly played out at the national and international levels by a new type of artist who moves freely about, living on or off the reserve, and who recognizes the unlimited potential of art to express—poignantly and critically, personally or universally, locally or pan-tribally—issues, situations, and perspectives that go beyond tradition. What differentiates these artists from those of previous generations is their relation to a complex world outside the traditional tribal framework, where they apply new visual languages and play in the force field called the art world.

These new artists have emerged from different backgrounds and have been shaped by various circumstances, but they are uniquely Anishinaabe. Some of them have been widely acknowledged as the voice of the people, since they have been constituted within colonial discourses. The artists presented here are not only carriers but also innovators of culture, living betwixt and between several cultures and communities: they find comfort in the mainstream, in local Aboriginal communities, and in liminal spaces between the two, where identity politics allows them to choose as their political point of departure a position with respect to their identities, as members of one or more groups.

At the same time, the artists derive their foundation from a profound consciousness of their social, historical, political, and cultural identity. Coterminous with these experiences are the artists' interrelations with Anishinaabe and non-Anishinaabe communities, where they assume positions with the recognition that such identity is discursively and politically paramount. While their connection to community often signifies continuity, other connections come from deep within their personal lives. Contests over the representations of personal and collective identity, and the categories through which identity is filtered, now come with the recognition that we all live in highly contestable spaces—spaces that continually collide and mix.

Excerpt from *Shrouds of White Earth*

Gerald Vizenor, one of America's foremost literary artists, belongs to the Minnesota Chippewa Tribe, White Earth Nation. His novels, narrative poems, and nonfiction have proven profoundly influential in the literary world and within the critical discourse of Native and Indigenous studies. He has generously allowed us to include in this book the following excerpt from his novel *Shrouds of White Earth*, published in 2010 by the State University of New York Press.

Vizenor's "concise play of the cosmoprimitive," as he put it, introduces us to Dogroy Beaulieu, a fictional, visionary painter from White Earth, who speaks of a recent solo exhibition in Paris. He describes in vivid language six paintings created for the show, each an homage to an icon of art history, each an opportunity for interventions that turn art history on its head. Vizenor evokes for us the situation of a worldly Anishinaabe artist who is thoroughly engaged with contemporary art and art history, yet who seeks through his work truths about his experiences as an Indigenous person, as an Anishinaabe, as an artist, and as a citizen of the contemporary world—themes that concern in some measure every artist featured in this book.

—David W. Penney

Yes, we agree, an original critical theory is necessary to perceive native visionary and narrative art, a theory that must forever sideline the romance of the primitive as native reality. Clearly that idea alone could be the start of a new art theory, Native Visionary Cosmopolitan Primitivism, or Cosmoprimitivism.

Please, sit with me in the studio. Favor has waited most of the day for me to return and paint, paint, paint. She counts the brushes several times a day. Breathy Jones is always at my side, easel or not, and would never give me that critical cat gaze. Breathy sneezes over the absence of irony, as you know, but he never counts my brushes. Favor teases the cat haters, to be sure, purrs with lovers, but she follows no one. Favor, and she is the favor of a painter, is the feline princess of the reproving gaze. I worry too much away from the easel, and try to avoid her gaze.

I created one triptych and painted six nude hyperbaroque portrayals in my *Homage Nu* series for the exhibition with the Provence artist Pierre Cayol at the Galerie Orenda in Paris. The gallery owners borrowed from private owners three of my shrouds, and several other paintings, including several portrayals from the series, *Body Counts*, and *Casino Walkers*, for the exhibition. The show opened late last summer and was a great success. The triptych and three of the six *Homage Nu* paintings sold in the first week.

That, my friend, was my very first international exhibition, and luckily the moment was shared with a brilliant original figural and abstract painter. Cayol, my good friend, perceives the world as a creative artist, and so we easily convey a union of chance and natural reason. He lovingly concentrates on the rush of natural light, contours, outlines, abstract landscapes, and the magical fusions of color. He once painted nudes, but our styles are not the same in any way. Many of my figures are in motion, some distorted, fleshy, and afloat in heavy waves of color. Cayol teases the very sentiments of color, textures, curves and figures, and his painterly touch creates a natural sense of balance.

The Galerie Orenda presents native artists in exhibitions with painters mostly from France. The gallery is located near the River Seine, the Pont des Arts, and Musée du Louvre. Paris and the exhibition was another union of chance for me, and, as you know, my sense of an artistic union was most prominently inspired by the marvelous creations of Marc Chagall.

My nudes for the exhibition were homage portrayals, fleshy teases of familiar portraits by six distinguished painters. The scenes of engorged figures pushed the capacity of the canvas, and the ordinary boundaries of perspective. Most of the enormous figures are painted in rosy fusions of color, over waves of blue veneer, and with thick, dark green in fleshy

creases and shadows. My homage portrayals tease familiar portraits by Rubens, Rembrandt, Jean Clouet, George Morrison, Otto Dix, and Fernando Botero. The portrayals are in motion, and shimmer with fleshy exuberance, the traces of memorable scenes by other artists. My brush strokes, outlines, contours, and colors, gentle, sometimes bold, and figures in motion, are not, as you know, comparable to any other painter.

Yes, the portrayals are aesthetic, figural traces, and visionary sensations, but not merely artistic representations. The painterly tease of familiar figures creates a sense of natural motion by color and contour. Really, the portrayals are traces of nature, visionary memories, and, of course, the homage afterimages of great works of art by prominent painters.

The triptych portrayal was sold to a private collector on the first day of the exhibition. The first panel is a wave of three cranes, blue, white, and green cranes, neck to neck, with huge bright blue human eyes, and the orange feet of children. The faint broken shadows of the cranes have red eyes. The cranes are in flight, and in the back scene a fusion of rosy clouds of a sunrise. The crest of a blue wave rushes with the clouds. The second panel is a crowd of massive deformed hunters, huge fleshy heads, hollow cheeks, torn ears, and with a faint vestige of military camouflage on their scarred faces. Three of the hunters face each other in a swamped birch bark canoe, and a single shadow of a blue crane is reflected in the cloudy eyes of the hunters. A Moccasin Flower, my artistic signature, is painted on the bark bow of the ratty canoe. The third panel of the triptych is a scene of bloody cranes, red and green wings cracked, feathers bent, blue hearts and fleshy chest muscles exposed in the gnarled hands of the hunters. The faces of the hunters are decomposed, a gruesome motion, black teeth, bare bones, loose, tangled muscles, revealed in heavy waves of blue, and fusions of green.

The exhibition crowd closely examined the triptych wave of cranes, and huge the hands of hunters, cracked and twisted, transparent bones, clots of glossy black and brown blood, and the showy wreathe of silver fingernails in the third panel.

I wore a perfect white shirt with a bright yellow collar that night, and wide black circus trousers, a floral beaded necklace, rough turquoise ring, and a huge blue wristwatch purchased duty free on the airline. Emily of Praise designed the yellow collar especially for the exhibition. The crowd was congenial but rather shied by my bare homage portrayals. Rightly so, every bloody, fleshy figure in the series was highlighted in the gallery.

The French are romantic about natives, and that sentiment is the vital mainstay of a tolerant and liberal culture, as you know, but my extreme

portrayals distracted the most eager patrons and sponsors of contemporary native art. My fleshy hyperbaroque nude portrayals, a tricky homage to *Bacchus* by Rubens, the distorted countenance of *François Premier* by Jean Clouet, and *Bathsheba at Her Bath* by Rembrandt, were the most curious, freaky, and yet marketable at the gallery.

My portrayals are sensations not representations.

Yes, you certainly have encouraged me in the past month to learn by heart several of my favorite quotations for our sessions here at the studio and at the Band Box Diner. Listen, Isaiah Berlin wrote in *The Roots of Romanticism*, "We owe to romanticism the notion of the freedom of the artist." I declare with you that straightforward, heartfelt sense of freedom, and for natives, continental liberty, and that is the emotive experience that creates light. That marvelous light of freedom, or *lumière-liberté*, that was mentioned by Chagall in Paris. Berlin continued with the ideas of "liberalism, toleration, decency," and the unpretentious appreciation of imperfections. Now, these ideas, my friend, should be stated in the Constitution of the White Earth Nation.

Peter Paul Rubens painted *Bacchus* in the seventeenth century, already baroque, corpulent and fleshy. My hyperbaroque homage, *Putto and Sumo Bacchus*, a portrayal of *Bacchus*, overstates the original museum representation of the Roman Bacchus, or the Greek Dionysus, in classical mythology, and, by my speedy reader of art history, the god of wine, a romancer and liberator, and an inspiration of ritual ecstasy. Surely that depiction would convey the obvious imperfections of dissipation and debauchery.

I told the curious crowd at the Galerie Orenda that my bold portrayal reveals debauchery, the blubbery, weighty suet of an older, and richly gorged, Bacchus. Surely, any homage to an artist must subvert the customary features and representations of painterly creations. Bacchus in my portrayal soars over a circle of nasty creatures, lions and wolves, with a cask of wine under his arm. His double folds of breasts, and giant green penis with swollen veins, dangle just above the bony, starved animals, a rudder of uncertain ecstasy, and putto, a cherub or naked child, pisses on a green lion.

The big dick is covered by strategic shrubbery in the original baroque picture, only the tiny dick of a putto is shown. The mythical creature has four folds of thick neck fat, blue in the creases of sacrifice, two more than the original by Rubens. My homage *Putto and Sumo Bacchus* would only be exhibited as ironic artwork by a museum. The *Bacchus* and *The Union of Earth and Water* by Rubens are secured at the State Hermitage Museum in Saint Petersburg, Russia.

The mighty truth games of national museums would never consider the traces and common associations of the baroque *Bacchus* by Rubens, and the hyperbaroque homage *Putto and Sumo Bacchus* by Dogroy Beaulieu in the same context of art, and certainly not secured or exhibited in the same museum. The original perception of *Bacchus,* a baroque breach of classical representations, has been established for three centuries, and the truth games are protective, solicitous to museums, and hardly encourage further estrangements of original and singular representations.

François Premier, King of France, has enormous shoulders, a mammoth monarch in a portrait by Jean Clouet. The breadth of his shoulders is a breach of realism and representations, an exaggerated mighty pose in ornamental, brocaded, and magisterial robes. The King has a huge angular nose, elongated almost to the level of his thin moustache, and his hands are willowy, a perfect portrait posture.

My hyperbaroque portrayal of the monarch is in homage of the original sixteenth century baroque golden portrait by Jean Clouet. The huge shoulders, stout neck, and squinty eyes, however, naturally invite a painterly examination of the bulky nude monarch, and so my portrayal, *The King on Bibb Lettuce,* is a sovereign salad.

François Premier is depicted in repose on giant leaves of blue lettuce, surrounded by olives, radishes, cucumbers, bright green worms, golden and silver coins, rosy grapes, rosary beads, emblem sweets of haloed saints, and the miniature schemes of Château de Chambord, Château d'Amboise, and Fontainebleau. The enormous shoulders and nude body shimmer in a green oil veneer. The King has a rouge tattoo of a moccasin flower on his rotund thigh, a native signature with a master salad of the kingdom. Overhead, tiny red birds float on the waves of cumulus clouds.

The massive royal penis is upright, blotched brown and rosy. Two butcher knives, and several silver skewers, one with a slice of bloody royal flesh, are at the side of the salad. A precise wedge of flesh has been cut and removed from the chest of the sovereign. The incision is cavernous, bloodies the blue leaves, and reveals the tawny organs and toothy creatures at the very heart of the monarchy.

François Premier was a sponsor of the Renaissance.

The French were curious, not outraged by the bloody mockery of the sixteenth century ruler as a salad order, and the portrayal sold in the first week of the exhibition at the Galerie Orenda. The irony of my hyperbaroque painterly style was appreciated, but the viewers were not as generous with their sense of irony over the romance of native cultures. This,

my friend, might be the actual reversal of the sentiments of native irony. The French may treasure the painterly irony about ancient royalty, but not the romance of natives. The natives may treasure the irony of romantic poses and simulations of their culture, but not so much the hyperbaroque simulations of sacred ceremonies and portraits of eminent warriors and political leaders. Maybe not, maybe the only distinction is by manners and time, not romance and simulations.

The most outrageous hyperbaroque portrayal at the exhibition, and the one that some gallery viewers shunned, is my homage to *Bathsheba at Her Bath* by Rembrandt. The painterly distortion of that lovely nude figure is rather cruel, if not crude, but, as you know, this is the ironic perspective, the precise sensation of the bare homage series of hyperbaroque portrayals. Bathsheba is at her bath in my portrayal, *Bathsheba at Her Birth Canal*, but not to merely observe a servant at her feet with ritual water. The scene and contours are similar to the original, but her rosy breasts and belly are enormous, and the colors are bolder for obvious reasons. Bathsheba is pregnant in the original, and she delivers in my portrayal. Her long hair is drawn back on her head, and, as in the original painting, she wears a simple thin necklace, and an amulet on her right arm.

Bathsheba holds a letter in one hand, and her fleshy legs are spread widely. The huge head and shoulders of a newborn child protrude from the bloody birth canal. The letter is blood stained, and the morose servant stands nearby with a heavy linen shroud to wrap around the blue child. Bathsheba is melancholy, and shows no evidence of pain. Her face is green, and decomposed, the huge teeth exposed, bluish, and broken in a withered grimace.

Otto Dix is portrayed in my homage series, *Trench Costume Party*, by two caricatures of nude soldiers in trenches of the First World War. The two caricatures are headless and surrounded by gory soldiers and putrefied body parts. The first caricature, a bony man, burned and blemished by war, and with a swollen green penis, holds under his arm bits of bloody backbone and the head of Otto Dix. Yes, a hideous portrayal, the face and features of a scared young man, straight, glossy black hair, and bulging, bright red eyes. The second headless caricature, an old woman with elongated breasts, and huge silver nipples, holds under one arm a broken gas mask, and under the other arm the second head of Otto Dix, a decomposed face, bright white teeth, and a giant pink bow in his tangled, ratty hair.

Fernando Botero, the renowned baroque painter, is portrayed in my homage, *Mona Lisa Melancholia*, as a stout, meaty man who wears a sum-

mer sundress with a delicate floral pattern. The painter is seated outside in the orange sunlight at Les Deux Magots on Place Saint Germain des Prés in Paris. His heavy black chest hair coils over the rickrack neckline decoration. The painter has a broad face, narrow nose, rosy cheeks, stocky arms and shoulders, and wide blue creases on his neck. His hair is thin and gray, and he has a short perfectly trimmed beard and moustache.

Botero is the master of artistic tease and ridicule, as you know, and the creation of corpulent caricatures. Yes, he has been menaced, and banished for his satirical portrayals of militarists, clergy, and politicians. Botero has been cursed by legislators, and shunned by some museum curators, mainly, and most recently, for his artistic depictions of the horrors of torture at Abu Ghraib in Iraq. He created a "permanent accusation" in eighty portrayals of military barbarity.

So, in a sense, it was much easier to create an ironic homage to Fernando Botero. I merely borrowed some of his narrative figures and reversed the obvious ironic scenes. The painter, in my homage, *Mona Lisa Melancholia*, is seated at a round silver table on the street with a giant bottle of Abu Rhône white wine close at his side. He wears golden slippers and his stout hairy legs are spread widely. A heavy green wine glass is tilted on the stem. The painter presents two portraits, one on each side of the table. The first portrait is the pudgy, pouting *Mona Lisa* by Fernando Botero, and the second is a narrative portrait, *Pow-wow Princess in the Process of Acculturation*, a generous native parody of the *Mona Lisa* by the Anishinaabe painter David Bradley.

George Morrison, the abstract expressionist, is the last artist in my homage series of hyperbaroque portrayals. This portrayal is a driftwood mosaic, and actually not very hyper or baroque. The Anishinaabe painter was born in Chippewa City, a native village near the Grand Portage Reservation. He discovered a natural provenance of art on the shore of Lake Superior, as you know, in northern Minnesota. He was an artist of natural light, the master of that eternal, elusive shimmer of the sunrise on the horizon.

Morrison was inspired by abstract expressionism, and that art movement was already underway by the time he arrived in New York to study at the Art Students League. Some native artists were envious for no other reason than he lived and painted near Greenwich Village. So, who would not be envious that he drank with Franz Kline, Willem de Kooning, Jackson Pollock, and other artists at the notorious Cedar Street Tavern near Washington Square? I was not aware of these artists in the early nineteen fifties. We were in the military at the time, and stationed in Japan. Hoku-

sai was the source of my inspiration, not the marvelous abstract expressionist Jackson Pollock.

Hello Dolly's was not the same.

Later, Morrison studied at the École des Beaux-Arts in Paris. My cryptic portrayal, *Driftwood Horizons*, is a mosaic of found driftwood from the shores of Lake Superior. I created the huge head of the painter, and his wide heavy ears, with tiny bits and pieces of natural driftwood, a matte mosaic of woody countenance. The face of the painter is wide and centered on the horizon. I imagined the shimmer of the horizon in the very wood that washed ashore and became his face. The eyes are mosaic ovals of miniature pieces of driftwood, every piece was found on the shores of Lake Superior.

The grotesque faces at the sides of the mosaic are Dennis Banks and Clyde Bellecourt of the American Indian Movement. Morrison was romantic about native activists, but he was never a celebrant of crude postindian warriors. So, the gray, woody, twisted cubist heads of the two militants are sardonic, to be sure, a natural native tease of abstract driftwood amity.

Yes, you are right, my friend, the wave on my easel is the actual start of a new series, *Eternal Waves*. The primary source of my idea for a wave series, of course, is the brilliant horizon series by George Morrison. The horizon is one of his signature series, and my signature series as a painter might become the wave. On the other hand, maybe my shrouds, or portrayals of nasty politicians as savage beasts, would become a more suitable signature. My primary visionary association, perception, and inspiration of waves for almost sixty years have been *The Great Wave of Kanagawa* by Hokusai. That wild, fierce, splendid isolation of a woodblock print of a wave has become my eternal memory of Mount Fuji and the distinct arts and creative literature of Japan.

This is my first creation and run with a painterly wave, so to speak, and my series will portray waves in many prominent and obvious places. Naturally, the first portrayal in the series is a massive wave at the headwaters of the Mississippi River at Lake Itasca. My *Itasca Wave*, similar in some ways to the *Kanagawa Wave*, carries boats, fish, and tourists on the great white crest. I may yet portray on the crest of the wave a stout caricature of the explorer Henry Rowe Schoolcraft. He determined the simulated name of the headwaters, a rather biased merger of two Latin words to concoct the name Itasca. The Anishinaabe, obviously, never lost the name and memory of the lake or the headwaters of the *gichi ziibi*, big, great river, the Mississippi River.

George Morrison (Grand Portage Band of Chippewa), 1919–2000. *Lucent Paramour. Infinite Magic. Red Rock Variation. Lake Superior Landscape* (detail), 1997. Acrylic on canvas; 76.2 x 157.5 cm. From the permanent collection of Aubrey Danielson

Favor noses, as you can see, and counts the brushes. Listen, she purrs loudly at the same time she counts. She counts the brushes in the morning, and then later in the day. Today must be special because she has nosed the brushes before lunch. Truly, the message is about food, not the ecstasy of brush hair, and maybe she purrs over too much talk and not enough paint. Favor seems to urge me to paint more and more because of my age and sense of mortality.

Now that my friend is a very good idea for the new series, the Band Box Diner and Hello Dolly's on the crest of a great wave in the city. Joêlle and Nicolas at the Galerie Orenda have always supported my work, they might invite me to show my series *Eternal Waves* in another exhibition with Pierre Cayol. Favor may be right, more paint, paint, paint and less conversation makes a better painter.

Notes

CORBIERE AND MIGWANS

1 The thunderbird is called *animikii* (plural: *animikiig*) in the Anishinaabe language. The western Ojibwe refer to the thunderbird as *binesi* (plural: *binesiwag*), the general word for raptors such as hawks, eagles, and falcons. Today, many combine these words for greater specificity: *animikii-binesi* (or *nimkii-bnesi* in the Manitoulin Island dialect). We suspect that this compound noun, and the need to specifically identify thunderers as birds, developed under the influence of the English language, whereas in historic times this meaning was implicit.

2 The underwater panther is called *mishibizhiw* (plural: *mishibizhiig* or *mishibizhiwag*). Also rendered as *mshibizhii* (in the Manitoulin Island dialect) or *meshepesheu*. This word has been translated as *underwater panther, great lynx, or great lion*.

3 Frances Densmore, "Chippewa Music," *Smithsonian Institution, Bureau of American Ethnography Bulletin*, no. 45 (Minneapolis: Ross and Haines, 1973): 16.

4 Wooden slabs or birchbark scrolls etched with mnemonic designs, documenting songs.

5 John Tanner, *Narrative of the Captivity and Adventures of John Tanner (U.S. Interpreter at the Saut de Ste. Marie): During Thirty Years Residence among the Indians in the Interior of North America* (New York: G. and C. and H. Carvill, 1830), 175. In John Tanner's 1830 account of his captivity among the Odawa, he recalled seeing a birchbark tag staked to the ground, marked with animals and symbols—a note, which he could read, communicating that his brother had killed someone and was in hiding.

6 Pippa Cruickshank, Vincent Daniels, and Jonathan King, "A Great Lakes Pouch: Black-dyed Skin with Porcupine Quillwork," *British Museum: Technical Research Bulletin* 3 (2009): 66.

7 Ted Brasser (paper presented at the *From the Four Quarters* exhibition symposium, Art Gallery of Ontario, Toronto, 1984).

8 Ruth Phillips, "Dreams and Designs: Iconographic Problems in Great Lakes Twined Bags," in *Great Lakes Indian Art*, ed. David W. Penney (Detroit: Wayne State University Press, 1989), 61.

9 William Jones, "Ojibwa Texts Collected by William Jones," in *Publications of the American Ethnological Society*, ed. Franz Boas, vol. #7, part 1 (New York: G. E. Stetchert, 1917), 257–59.

10 Elizabeth Panamick, interview by Evelyn Roy, Kinoomaadoog Cultural and Historical Research Project, M'Chigeeng, Ontario, 2003.

11 Maude Kegg, *Nookomis Gaa-Inaajimotawid: What My Grandmother Told Me, with Texts in Ojibwe (Chippewa) and English* (Bemidji, MN: Bemidji State University, 1990), 14–15.

12 Ibid., 119.

13 In this altered state, the person who has turned *wiindigoo* perceives an individual not as human but as the animal that represents the person's clan. So a person of the Bear Clan is seen by the wiindigoo as a bear, and the wiindigoo, who is starving, thinks he is eating a bear instead of a human.

14 John Nichols and Earl Nyholm, *A Concise Dictionary of Minnesota Ojibwe* (Minneapolis: University of Minnesota Press, 1994), 54.

15 John Esquimaux, "A Story about the Between People," February 1893. Bell Papers, Vol. 54, MG 29 B15, File 5, Library and Archives of Canada, Ottawa, Ontario.

16 Henry R. Schoolcraft, *Historical and Statistical Information Respecting the History, Condition, and Prospects of the Indian Tribes of the United States*, (Philadelphia: Lippincott, Gambo, 1851), 1: 406.

17 Cory Silverstein (Willmott), "Ojibwe Thunderers: Persons of Power," in North American Indians: Cultures in Motion, ed. Elvira Stefania Tiberini, *L'Uomo: Società Tradizione Sviluppo* n.s. 8, no. 1 (1995): 107.

18 Elizabeth Panamick, interview by Evelyn Roy, Kinoomaadoog Cultural and Historical Research Project, M'Chigeeng, Ontario, 2003.

19 For a description of the white panther in the re-creation tale, see George Gabaossa, "Nanabosho Myth," 1921, MS 1637, National Anthropological Archives, Smithsonian Institution. For a description of the copper-tailed panther, see Fred Ettawageshik in Gertrude Kurath, Jane Ettawageshik, and Fred Ettawageshik, *The Art of Tradition: Sacred Music, Dance and Myth of Michigan's Anishinaabe, 1946–1955* (East Lansing: Michigan State University Press, 2009).

20 Diamond Jenness, *The Ojibwa Indians of Parry Island: Their Social and Religious Life* (Ottawa: J. O. Patenaude, 1935); and Theresa Smith, *The Island of the Anishinaabeg: Thunderers and Water Monsters in the Traditional Ojibwe Life-World* (Moscow: University of Idaho Press, 1995).

PHILLIPS

1. A. Irving Hallowell, "Ojibwa Ontology, Behavior and World View," in *Contributions to Anthropology: Selected Papers of A. Irving Hallowell*, ed. Stanley Diamond (Chicago: University of Chicago Press, 1976), 357–90. The phrase is that of anthropologist Irving Hallowell, based on his research among the Berens River Ojibwe of northwestern Ontario in the 1930s.

2. Franz Boas, *Primitive Art* (1927; repr., New York: Dover, 1955), 10.

3. Bill Brown, "Thing Theory," *Critical Inquiry* 28 (Fall 2001): 1–22.

4. Alfred Gell, *Art and Agency: An Anthropological Theory* (Oxford: Clarendon, 1998).

5. Igor Kopytoff, "The Cultural Biography of Things: Commoditization as Process," in *The Social Life of Things*, ed. Arjun Appadurai (Cambridge, MA: Cambridge University Press, 1986), 64–94.

6. François-Marc Gagnon, "Introduction: Louis Nicholas's Depiction of the New World in Figures and Text," in *The Codex Canadensis and the Writings of Louis Nicholas*, ed. François-Marc Gagnon (Montreal: McGill Queen's University Press, 2011), 23.

7. Ibid., 75.

8. The largest group is in the Musée du Quai Branly and derives from aristocratic and royal collections confiscated at the time of the French Revolution. Other examples were collected by eighteenth-century soldiers and other curiosity collectors. See, for example, the bags collected by Sir John Caldwell, now in the Canadian Museum of Civilization and one with a double netted panel in the collection at the Schloss um Garten Wörlitz. On the distinctions between Anishinaabe and European understandings of and terms for divinities and spiritual beings, see Teresa Schenk, "Gizhe-Manidoo, Missionaries, and the Anishinaabeg," in *Anishinaabewin NIIZH*, ed. Alan Corbiere, Deborah McGregor, and Crystal Migwans (M'Chigeeng, Ontario: Ojibwe Cultural Foundation, 2012), 39–47.

9. Ruth Landes, *The Ojibwa Woman* (New York: Columbia University Press, 1938), 155.

10. Christi Belcourt's website, comment on *Not One of Us the Same*, 2003 (private collection), accessed May 17, 2008, http://www.christibelcourt.com/Gallery/gallery2000page2c.html.

11. Johann Georg Kohl, *Kitchi-Gami: Life among the Lake Superior Ojibway*, trans. Lascelles Wraxall (London: Chapman and Hall, 1860; repr., Minneapolis: Minnesota Historical Society Press, 1985), 15.

12. A. Irving Hallowell, "Ojibwa Ontology, Behavior, and World View," 361.

13 Arni Brownstone, "Mysteries of Sculptural Narrative Pipes from Manitoulin Island," *American Indian Art Magazine* 36 (Summer 2011): 54–63, 84.

14 Maureen Matthews and Roger Roulette, "Aaajitaawinan izhiitwaawining: Material Culture of the Pimachiowin Aki Region" (discussion paper for the Pimachiowin Aki UNESCO World Heritage Site bid, August 2010).

McMASTER

1 New evaluative techniques helped us write texts in specific ways that would ensure accessibility. This eventually led to the DIA's commissioning evaluations with two Anishinaabe communities: the Zebwing in northern Michigan and the Ojibwe Cultural Foundation on Manitoulin Island.

2 *First Nations* and *Native American* are Canadian and American usages, respectively. In some instances, I use the commonly accepted legal term *Aboriginal* to refer globally to First Nation, Inuit, and Métis in Canada. In addition, I use *Indigenous* when referring to the Native peoples of Canada and the United States. Similarly this book uses the word *Anishinaabeg* to refer to people from the Ojibwe, Chippewa, Ottawa, Odawa, Algonquin, and Potawatomi nations.

3 Gerald McMaster, "Art History through the Lens of the Present," in *Building Diversity in Museums: Journal of Museum Education* 34, no. 3 (2009): 215–22.

4 *S'abadeb—The Gifts: Pacific Coast Salish Art and Artists*, 2009, Seattle Art Museum; *Out of the Mist: Treasures of the Nuuchah-nulth Chiefs*, 2010, Royal British Columbia Museum; *Across Borders: Beadwork in Iroquois Life*, 1999, McCord Museum; *Haida Art: Mapping an Ancient Language*, 2006, McCord Museum.

5 Morrisseau also was known by his Anishinaabe traditional name, Miskwaabik Animikii, or Copper Thunderbird, which he signed in syllabic form: ᒥᐢᑳᐱᐠ ᐊᓂᒥᑮ.

6 Morrison's Anishinaabe-language name was Wah Wah Teh Go Nay Ga Bo.

7 As an art student at the Minneapolis College of Art and Design (MCAD) in the mid-1970s, I frequently visited the Minneapolis Institute of Arts. I remember most clearly two works: the first is Egon Schiele's *Portrait of Albert Paris von Gütersloh* (1918), showing Gütersloh seated with both arms raised, hands turned in and out. From then on, I was a fan of Schiele. The second work is George Morrison's *Collage IX: Landscape* (1974). Clearly it had been recently acquired, since I was at MCAD from 1975 to 1977. I remember the work being located near a window, so at night I would find myself staring at it many times.

8 Greg Hill, ed., *Norval Morrisseau—Shaman Artist* (Ottawa: National Gallery of Canada, 2006), 21.

9 Elizabeth McLuhan, "The Emergence of the Image Makers," in Elizabeth McLuhan and Tom Hill, *Norval Morrisseau and the Emergence of the Image Makers* (Toronto: Art Gallery of Ontario, 1984), 49.

10 The conversation took place during the summer of 1982 at Pollock's home in Toronto. I was searching for another of Morrisseau's works but came across this one, which is now in the McMichael Collection. Pollock himself thought it was one of Morrisseau's finest works.

11 John Tootoosis was a highly respected Plains Cree elder from the Poundmaker First Nation. The conversation took place around 1977, when I was beginning work at Saskatchewan Indian Federated College, now called First Nations University. This crossing-over to depict the spiritual world is uncommon among Plains Cree, as such ideas are usually reserved for sacred objects.

12 The Saulteaux are related to the Anishinaabe culturally but located near the Plains and prairies; consequently, their art reflects a mix of two cultural areas.

13 The other four works in the series include *British North America Act 1867*, *Treaty No. 1 1871*, *Indian Act 1876*, and *Constitution Act 1982*.

14 Specific Claims Law, "Royal Proclamation, 1763," accessed April 5, 2013, http://www.specific-claims-law.com/specific-claims-background/12-royal-proclamation-1763.

 The terms *reserve* or *reserved* are used in the proclamation seven times, such as in this excerpt: "And whereas it is just and reasonable, and essential to our Interest and the Security of our Colonies, that the several Nations or Tribes of Indians with whom We are connected, and who live under Our Protection, should not be molested or disturbed in the Possession of such Parts of Our Dominions and Territories as not having been ceded to or purchased by Us, are reserved to them or any of them as their Hunting Grounds."

15 Ruth Phillips, "What Is 'Huron Art'? Native American Art and the New Art History," *Canadian Journal of Native Studies* 9, no. 2 (1989): 178–179.

16 McLuhan, "The Emergence of the Image Makers," in McLuhan and Hill, *Norval Morrisseau*, 108.

17 Beginning in 1978 at a gathering on Manitoulin Island and continuing into the next decade, Aboriginal artists came together to voice their displeasure at being marginalized. This eventually led to the formation of the Society of Canadian Artists of Native Ancestry (SCANA).

18 Lucy Lippard, *Mixed Blessings: New Art in a Multicultural America* (New York: Pantheon, 1990), 4.

19 Russell Ferguson, Martha Gever, Trinh T. Minh-ha, and Cornel West, eds., *Out There: Marginalization and Contemporary Cultures* (New York: New Museum of Contemporary Art, 1990), 7.

20 The "s" word is *squaw*. The word has been used throughout history in very negative ways to suggest a promiscuous or immoral Native woman. While the original word *squa* meant *woman* in Massachusett, an Algonquian language spoken by the indigenous people of eastern Massachusetts, its meaning has taken off uncontrollably in negative directions. It is pronounced *iskwew* in my Plains Cree language.

21 In 2004, I curated an exhibition at the National Museum of the American Indian in New York called *New Tribe: New York*, which featured the lives and work of the founders of Spiderwoman Theater. They were the first to bring the combination of theater, art, and Native women's issues to the public.

22 In 1995, I was the Canadian commissioner to the Venice Biennale, which featured the work of Métis artist Edward Poitras, who was the first artist of Aboriginal ancestry to be selected to represent Canada.

23 Personal conversation conducted at the Art Gallery of Ontario, fall 2008.

24 Devine is the founding chair of the Aboriginal Visual Culture Program at the Ontario College of Art and Design University, Toronto.

25 Gerald McMaster, "Cruel Beauty: New World Holocaust," in *Ruth Cuthand: Back Talk* (Saskatoon, Saskatchewan: Mendel Art Gallery/Tribe, 2012), 71–83. In this essay, I examine Cuthand's 2009 Trading series, in which her abstract circular beadwork patterns represent microscopic views of diseases imported by early Europeans.

26 Linda M. Mora and Deanna Reder, *Troubling Tricksters: Revisioning Critical Conversations* (Waterloo, Ontario: Wilfred Laurier University Press, 2010), 24.

27 Rosenquist was in Fargo to receive an honorary degree from North Dakota State University, and Wallowing Bull was having an exhibition at the Plains Art Museum. Wallowing Bull invited Rosenquist to his studio, where the latter purchased a painting.

Credits

Contributors

ALAN CORBIERE

Alan Ojiig Corbiere (Bne doodem [Ruffed Grouse Clan]) is an Anishinaabe from M'Chigeeng First Nation on Manitoulin Island. He was educated on the reserve and then attended the University of Toronto for a bachelor of science. He earned his master's degree in environmental studies at York University. During his masters studies he focused on Anishinaabe narrative and Anishinaabe language revitalization. Mr. Corbiere has studied the Ojibwe language for many years and has attained some measure of fluency. For five years he served as the executive director of the Ojibwe Cultural Foundation in M'Chigeeng, a position that encompassed the roles of curator and historian. Currently he is the Anishinaabemowin revitalization program coordinator at M'Chigeeng First Nation.

GERALD McMASTER

Curator, artist, and writer, Gerald McMaster (Plains Cree and member of the Siksika Nation) was co–artistic director of the highly acclaimed Biennale of Sydney in Australia (2012). At the Art Gallery of Ontario, he was the lead curator of the celebrated Canadian galleries rehang (2008), and he curated *Inuit Modern: The Samuel and Esther Sarick Collection* (2011). At the Smithsonian's National Museum of the American Indian, he led the successful installation of the permanent exhibitions, and he curated *First American Art* (2004) and *New Tribe/New York* (2005). At the Canadian Museum of Civilization he was the lead curator of the First Peoples Hall installation and the curator of such exhibitions as *Indigena* (1992) and *Reservation X* (1997). In 1995 he served as the Canadian commissioner to the Venice Biennale.

CRYSTAL MIGWANS

Crystal Migwans (Anishinaabe of Wikwemikong Unceded First Nation), a recent graduate of Carleton University, Ottawa, is currently a PhD student of Indigenous art history at Columbia University. From 2009 to 2011 she served as a curatorial assistant at the Ojibwe Cultural Foundation at M'Chigeeng First Nation on Manitoulin Island. She continues to collaborate in organizing its annual conference, Anishinaabewin, and in publishing its proceedings. She is also an active member of the Great Lakes Research Alliance for the Study of Aboriginal Arts and Culture.

DAVID W. PENNEY

An internationally recognized scholar of American Indian art, David W. Penney is the associate director of museum scholarship at the Smithsonian's National Museum of the American Indian. Formerly the vice president of exhibitions and collections strategies at the Detroit Institute of Arts and the longtime curator of that museum's Native American art collections, he is the coauthor of *North American Indian Art* (2004) and the author of *The American Indian: Art and Culture between Myth and Reality* (2012), which accompanied an exhibition that he curated at De Nieuwe Kerk in Amsterdam. An adjunct professor of art history at Wayne State University from 1989 to 2000, he has written many other books, exhibition catalogues, and published essays.

RUTH B. PHILLIPS

One of the first in Canada to teach the history of Indigenous North American art, Ruth B. Phillips is the Canada Research Chair in Aboriginal Arts and Cultures and a professor of art history at Carleton University in Ottawa. From 1997 to 2003, she served as the director of the Museum of Anthropology at the University of British Columbia, where she also was a professor of anthropology and art history. Her research and publications focus on museum representation and Anishinaabe and Haudenosaunee artistic traditions of the Great Lakes region. She is the author of, among many other books, *Trading Identities: The Souvenir in Native North American Art from the Northeast, 1700–1900* (1997) and *Museum Pieces: Toward the Indigenization of Canadian Museums* (2011).

GERALD VIZENOR

Gerald Vizenor, a citizen of the White Earth Nation, has during the past forty years profoundly influenced the study of American literature and Indigenous cultures. He is the author of more than thirty books, ranging from poetry collections to criticism to translations of tribal tales to novels. Vizenor is a Distinguished Professor of American Studies at the University of New Mexico, Albuquerque, and Professor Emeritus at the University of California, Berkeley. He was the principal writer of the Constitution of the White Earth Nation. One of his recent novels, *Shrouds of White Earth*, won an American Book Award in 2011.

Selected Bibliography

Bloom, Ken. *Drawings of Frank Big Bear.* Duluth: Tweed Museum of Art, 2009.

Boas, Franz. *Primitive Art.* Oslo: H. Aschehoug for the Oslo Institute for Comparative Research in Human Culture, 1927. Reprint, New York: Dover, 1955.

Brasser, Ted J. *Bo'jou, Neejee!: Profiles of Canadian Indian Art.* Ottawa: National Museum of Man, 1976.

Brown, Bill. "Thing Theory." *Critical Inquiry* 28 (Fall 2001): 1–22.

Brownstone, Arni. "Mysteries of Sculptural Narrative Pipes from Manitoulin Island." *American Indian Art Magazine* 36 (Summer 2011): 54–63, 84.

Cruickshank, Pippa, Vincent Daniels, and Jonathan King. "A Great Lakes Pouch: Black-dyed Skin with Porcupine Quillwork." *British Museum: Technical Research Bulletin* 3 (2009): 63–72.

Densmore, Frances. *Chippewa Music.* Bulletin, Smithsonian Institution, Bureau of American Ethnology, nos. 45, 53. Washington, DC: Government Printing Office, 1910–13. Reprint, Minneapolis: Ross and Haines, 1973.

Devine, Bonnie. *Daphne Odjig: A Retrospective Exhibition.* Ottawa: National Gallery of Art, 2007.

Ferguson, Russell, Martha Gever, Trinh T. Minh-ha, Cornel West, eds. *Out There: Marginalization and Contemporary Cultures.* New York: New Museum of Contemporary Art, 1990.

Gagnon, François-Marc. "Introduction: Louis Nicholas's Depiction of the New World in Figures and Text." In *The Codex Canadensis and the Writings of Louis Nicholas,* edited by François-Marc Gagnon. Montreal: McGill Queen's University Press, 2011.

Gell, Alfred. *Art and Agency: An Anthropological Theory.* Oxford: Clarendon, 1998.

Graham, Steve. *Ottawa Quill Work on Birchbark.* Harbor Springs, MI: Harbor Springs Historical Commission, 1983.

Hallowell, A. Irving. "Ojibwa Ontology, Behavior, and World View." In *Contributions to Anthropology: Selected Papers of A. Irving Hallowell,* edited by Stanley Diamond, 357–90. Chicago: University of Chicago Press, 1976.

Harbor Springs Historical Commission. *Beadwork and Textiles of the Ottawa.* Harbor Springs, MI: Harbor Springs Historical Commission, 1984.

Hill, Greg A. *Carl Beam: Poetics of Being.* Ottawa: National Gallery of Canada, 2011.

———. *Norval Morrisseau: Shaman Artist.* Ottawa: National Gallery of Canada, 2006.

Jenness, Diamond. *The Ojibwa Indians of Parry Island: Their Social and Religious Life.* Ottawa: J. O. Patenaude, 1935.

Jones, William. "Ojibwa Texts Collected by William Jones." In *Publications of the American Ethnological Society,* edited by Franz Boas. Vol. 7, part 1. New York: G. E. Stetchert, 1917.

Kegg, Maude. *Nookomis Gaa-Inaajimotawid: What My Grandmother Told Me, with Texts in Ojibwe (Chippewa) and English.* Bemidji, MN: Bemidji State University, 1990.

Kohl, Johann Georg. *Kitchi-Gami: Life among the Lake Superior Ojibway.* Translated by Lascelles Wraxall. London: Chapman and Hall, 1860. Reprint, Minneapolis: Minnesota Historical Society Press, 1985.

Kopytoff, Igor. "The Cultural Biography of Things: Commoditization as Process." In *The Social Life of Things,* edited by Arjun Appadurai, 64–94. Cambridge, MA: Cambridge University Press, 1986.

Kurath, Gertrude, Jane Ettawageshik, and Fred Ettawageshik. *The Art of Tradition: Sacred Music, Dance, and Myth of Michigan's Anishinaabe, 1946–1955.* East Lansing: Michigan State University Press, 2009.

Landes, Ruth. *The Ojibwa Woman.* New York: Columbia University Press, 1938.

Lippard, Lucy. *Mixed Blessings: New Art in a Multicultural America*. New York: Pantheon, 1990.

McLuhan, Elizabeth and Tom Hill. *Norval Morrisseau and the Emergence of the Image Makers*. Toronto: Art Gallery of Ontario, 1984.

McMaster, Gerald. "Art History through the Lens of the Present." In "Building Diversity in Museums." Special issue, *Journal of Museum Education* 34, no. 3 (2009): 215–22.

———. "Cruel Beauty: New World Holocaust." In Joan Borsa, Lee-Ann Martin, Gerald McMaster, and Jen Budney, *Ruth Cuthand: Back Talk, Works, 1983–2009*, 71–83. Saskatoon, SK: Mendel Art Gallery/Tribe, 2012.

Mora, Linda M. and Deanna Reder. *Troubling Tricksters: Revisioning Critical Conversations*. Waterloo, ON: Wilfred Laurier University Press, 2010.

Morrison, George and Margot Fortunato Galt. *Turning the Feather Around: My Life in Art*. St. Paul: Minnesota Historical Society Press, 1998.

Nichols, John and Earl Nyholm. *A Concise Dictionary of Minnesota Ojibwe*. Minneapolis: University of Minnesota Press, 1994.

Penney, David W., ed. *Great Lakes Indian Art*. Detroit: Wayne State University Press, 1989.

Phillips, Ruth B. "Dreams and Designs: Iconographic Problems in Great Lakes Twined Bags." In *Great Lakes Indian Art*, edited by David W. Penney, 53–68. Detroit: Wayne State University Press, 1989.

———. *Patterns of Power: The Jasper Grant Collection and Great Lakes Art of the Early Nineteenth Century*. Kleinburg, ON: McMichael Canadian Art Collection, 1984.

———. *Trading Identities: The Souvenir in Native North American Art from the Northeast, 1700–1900*. Seattle: University of Washington Press, 1998.

———. "What Is 'Huron Art'? Native American Art and the New Art History." *Canadian Journal of Native Studies* 9, no. 2 (1989): 161–86.

Schenk, Teresa. "Gizhe-Manidoo, Missionaries, and the Anishinaabeg." In *Anishinaabewin NIIZH*, edited by Alan Corbiere, Deborah McGregor, and Crystal Migwans, 39–47. M'Chigeeng, ON: Ojibwe Cultural Foundation, 2012.

Schoolcraft, Henry R. *Historical and Statistical Information Respecting the History, Condition, and Prospects of the Indian Tribes of the United States*. 6 vols. Philadelphia: Lippincott, Gambo, 1851. http://openlibrary.org/books/OL16694989M/Historical_and_statistical_information_respecting_the_history_condition_and_prospects_of_the_Indian_.

Silverstein (Willmott), Cory. "Ojibwe Thunderers: Persons of Power." In "North American Indians: Cultures in Motion," edited by Elvira Stefania Tiberini. Special issue, *L'Uomo: Società Tradizione Sviluppo* n.s. 8, no. 1 (1995).

Smith, Theresa. *The Island of the Anishinaabeg: Thunderers and Water Monsters in the Traditional Ojibwe Life-World*. Moscow: University of Idaho Press, 1995.

Southcott, Mary E. *The Sound of the Drum: The Sacred Art of the Anishnabec*. Erin, ON: Boston Mills Press, 1984.

Tanner, John. *A Narrative of the Captivity and Adventures of John Tanner (U.S. Interpreter at the Saut de Ste. Marie): During Thirty Years Residence among the Indians in the Interior of North America*. New York: C. and G. and H. Carvill, 1830.

Index

Page numbers in *italics* indicate illustrations.